CREATIVE PILGRIMAGE

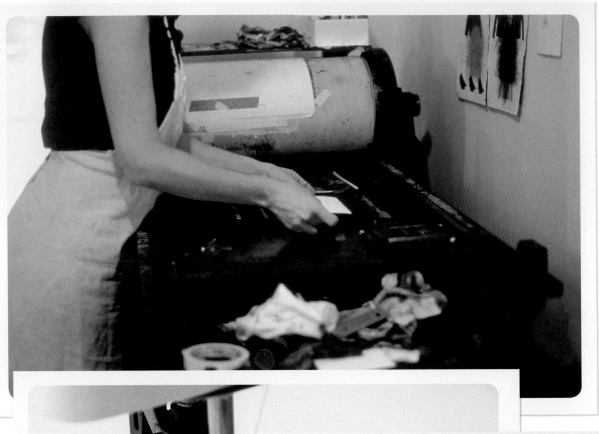

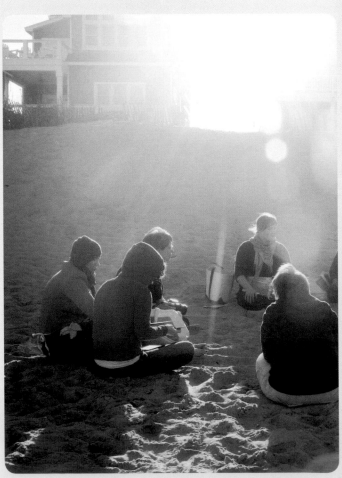

CREATIVE PILGRIMAGE

An Exploration of Artful Gatherings
& Discovery of Innovative Art Techniques

JENNY DOH

Quarry Books
100 Cummings Center, Suite 406L
Beverly, MA 01915

quarrybooks.com • craftside.typepad.com

First published in the United States of America in 2012 by
Quarry Books, a member of
Quayside Publishing Group
100 Cummings Center
Suite 406-L
Beverly, Massachusetts 01915-6101
Telephone: (978) 282-9590
Fax: (978) 283-2742
www.quarrybooks.com
Visit www.Craftside.Typepad.com for a behind-the-scenes peek at our crafty world!

10 9 8 7 6 5 4 3 2 1

ISBN: 978-1-59253-753-2

Digital edition published in 2011
eISBN-13: 978-1-61058-193-6

Library of Congress Cataloging-in-Publication Data
Doh, Jenny.
 Creative pilgrimage : an exploration of artful gatherings and discovery of innovative art techniques / Jenny Doh.
 p. cm.
 ISBN-13: 978-1-59253-753-2 (pbk.)
 ISBN-10: 1-59253-753-7 ()
 1. Artisans—Biography. 2. Art--Technique. I. Title.
 TT139D64 2012
 745.5092'2--dc23

2011031317

EDITORS: Jenny Doh and Sarah Meehan

ASSISTANT EDITORS: Monica Mouet, Jana Holstein, Belle Bryant, Melody M. Nuñez

DESIGNER: Raquel Joya

PROJECT PHOTOGRAPHER: Cynthia Shaffer

Printed in China

On August 14, 1974, I landed on American soil after a long flight from my homeland of Seoul, Korea. I was seven years old at the time, and on that plane with me were my two older brothers and my parents. We were an immigrant family who had said goodbye to all that we knew in our decision to take a risk to discover the magnificence of the unknown.

Decades later, I'm able to reflect on the opportunities that became real for me and my family as we found success in business, education, and friendship. This success was mixed with tears, sweat, and struggle as each of us had to master new skills, break through communication barriers, and dust ourselves off from occasional falls.

The act of taking leaps to embark on a pilgrimage is never easy. Because on the road to success, there will undoubtedly be challenges along the way, as you come face to face with conquering the unknown.

In this book, *Creative Pilgrimage*, you'll discover the unique stories of fourteen exciting mixed-media artists, related to their pursuits of preparing and offering their art and techniques as teachers within the art world. They are: **Alisa Burke**, **Julie Haymaker Thompson**, **Lisa Kaus**, **Mary Beth Shaw**, **Maya Donenfeld**, **Roxanne Padgett**, **Sarah Ahearn Bellemare**, **Stephanie Jones Rubiano**, **Tracie Lyn Huskamp**, **Heather Smith Jones**, **Carla Sonheim**, **Mati Rose McDonough**, **Alma Stoller**, and **Flora Bowley**. The common lesson that these teachers have learned through their journeys is that as they give and teach, they receive and learn. You will also enjoy learning the valuable signature techniques of the contributing artists through the project-based workshops that are presented in their profiles.

Interspersed within the artists' stories and techniques are profiles of eight creative gatherings from across the nation. They are: **Squam Art Workshops**, **The Makerie**, **Artfest**, **An Artful Journey**, **Artistic Bliss**, **Valley Ridge Art Studio**, **Art & Soul**, and **Silver Bella**. Through these profiles, you'll get a unique behind-the-scenes glimpse of what makes each event so popular and special. The coordinators of these events work hard to bring together all the components to organize experiences where you learn to make things, but most importantly, where you develop friendships.

I dedicate this book to the courageous spirit of discovery within us all—the spirit that helps us put aside our insecurities and imperfections as we take a leap of faith in our quest to learn, to teach, to grow. May this book remind us that the time will *never* be perfect, but the time will *always* be now, to embark on pilgrimages big and small.

Jenny Doh

table of contents

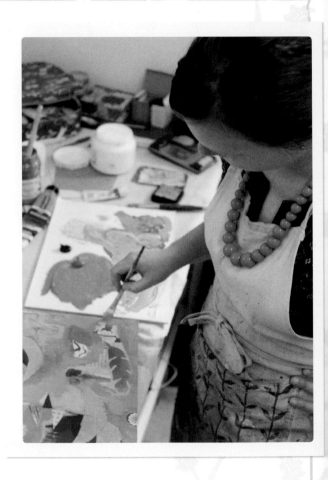

CREATIVE PILGRIMAGE

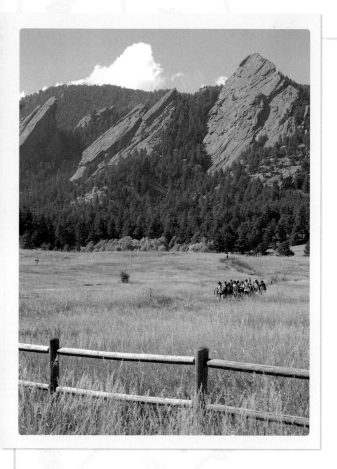

GATHERINGS

ALISA BURKE

HER ESSENCE

In high school, Alisa Burke had an English teacher, Mr. Broderick, who was a little bit eccentric, a lot creative, and completely unconventional. Alisa explains that he was her favorite teacher because his love for what he was teaching was so immense that his enthusiasm became contagious for her and the rest of the students. "He inspired his students to savor the books as we read and challenged us to be creative in our writing," she says. "I can only dream of capturing even a little bit of his essence in my own teaching. I know that every class I teach, I approach with passion and know that my love of creating always spreads to my students."

IMAGINING NEXT

Whether it is online or in person, Alisa puts her heart and soul into developing projects and presenting techniques that are bold, colorful, fresh, and very well prepared. Daily on her popular blog, Alisa also shares tutorials that involve all sorts of techniques and media. Arguably, the one art medium that could be classified as her go-to would be canvas. And paint. And fabric. And rubber stamps. And maybe paper. And ... well ... she sort of does it all.

"The beginning is always today."
—*Mary Wollstonecraft*

Her creative roots definitely have a connection with canvas, as she has been able to masterfully manipulate it as she paints, cuts, rips, shreds, and sews on it to demonstrate its versatility. With the completion of one project, Alisa's imagination takes her to the next one as she applies lessons learned to something new and exciting.

POINT OF VIEW

Alisa's keys to inspired and authentic living

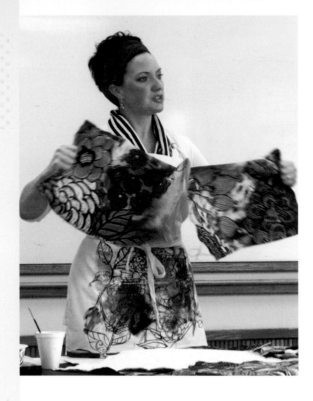

- It's important to give yourself permission to go with the ebb and flow of the process. Sometimes I am really productive while other times I slow down, step away, change things up, and accept that I cannot always be in "art-making mode."

- For me, it's all about just being myself, living with purpose and joy, and giving myself to others.

- I really want to always be evolving in my art and my teaching. I plan on finding new and different ways to teach unique things and challenge students to think differently about what it means to make art.

WILD, MESSY, INVOLVED

Alisa loves the process of teaching and learning, and believes that many students take a pilgrimage to the classes they seek because they want to get to know a teacher in a way that only a live setting can provide. "I think they also want to connect and share the experience with others," she says.

Once students enter her classes, they soon become part of a group dynamic that is typically overflowing with energy, as the classes get wild, messy, and involved. "My goal is for everyone to have fun, to feel comfortable exploring, letting go, and just giving into the process," she says. "So far, my experience with the class dynamic is that always by the end of the day, the entire class has bonded, and everyone is glowing and excited about everything they created."

FOCUSED ON PROCESS

The first class that Alisa ever taught was a workshop for college students. A tough crowd that made Alisa nervous. She explains: "At the beginning, they were talking and distracted but once I got going, they warmed up, focused, and ended up staying after class to finish their projects. Since that experience, I have never once gotten nervous again."

These days, Alisa teaches lots of different types of techniques. From art quilting to collage to color theory and more. With every class she teaches, Alisa walks away amazed at how different each and every person translates the things that they learn. "Watching the students create and discover their own style is a true testament to how special the creative process is," she says. "I walk away inspired with more energy in my own creative process."

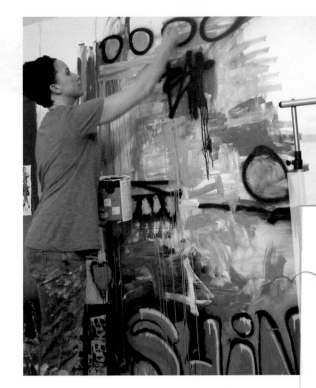

she laughs

Recently, I had a student painting and experimenting with splattering paint and she went a little overboard and ended up splattering and flinging paint all over the ladies who were working with her. It was in their hair, on their clothing, and pretty much everywhere!

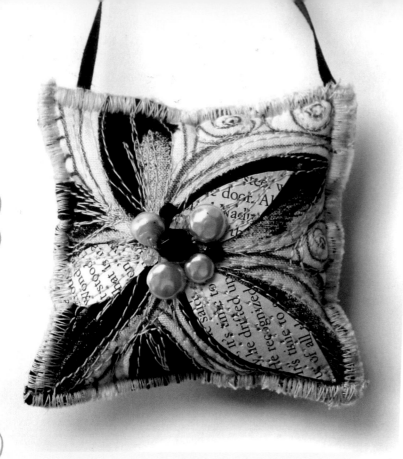

CREATING WITH ALISA:
HAND-PAINTED FREE MOTION ORNAMENTS

This project makes use of simple surface design techniques to create unique fabric that is cut up and sewn into pretty little ornaments. The use of free motion sewing and incorporation of vintage book text add interesting layers to the overall surface design.

what you'll need

- large piece of plain white cotton fabric
- black acrylic paint
- paintbrush
- rubber stamps (optional)
- black permanent marker
- scissors
- 2 pieces of batting, each 4 x 4 inches (10.16 x 10.16 cm)
- sewing machine with darning foot
- basic sewing supplies
- vintage book pages
- assorted beads
- hand needle and thread
- ribbon, 8½ inches (21.59 cm)
- polyester fiberfill

techniques you'll learn

- painting
- free motion stitching
- sewing

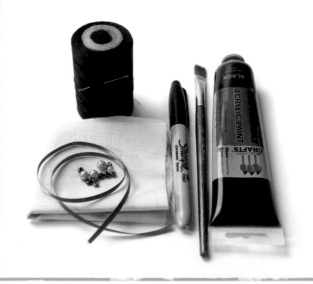

one

Paint assorted designs with black acrylic paint and paintbrush onto a piece of plain white cotton fabric to design a custom piece of fabric. Use other mark-making tools like rubber stamps.

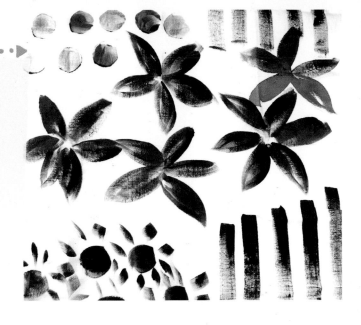

two

Allow the paint to dry and then add small details with a black permanent marker.

three

Cut this fabric with scissors into pieces that measure approximately 4 x 4 inches (10.16 x 10.16 cm).

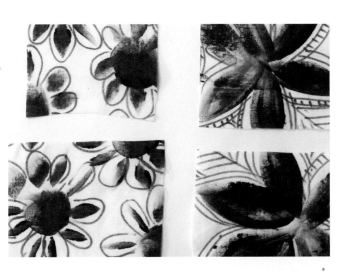

four

Select two pieces of cut fabric and decide which piece will be the back side of the ornament and which piece will be the front side. Place each side onto a piece of batting. Lower the feed dogs of your sewing machine, place the darning foot on, and free motion stitch designs onto the layers of fabric and batting.

five

Cut shapes out of vintage book pages and free motion stitch onto the layers.

create with Alisa at:

- Inspired Artist Workshop (*www.donnadowney.com/index.php/inspired-artists-workshops*)
- Cloth Paper Scissors CREATE Retreat (*www.clothpaperscissorsretreat.com*)

six

Stitch assorted beads onto the prepared front side of the ornament.

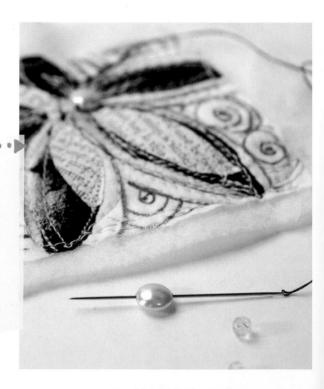

seven

Sew the front and back sides of the stitched squares together with a tight zigzag stitch. Position ribbon at the top edge while you are sewing so that the ribbon gets anchored into the layers.

ideas & variations

- Use as an ornament to hang on a doorknob or use in home décor.
- Create a slightly larger version and leave the top edge open to create a pouch for a laptop or an e-reader.
- Use multiple squares to create a larger wall hanging.
- Stitch multiple squares together to create a fabric book.

eight

Leave a small opening while sewing the pieces together through which you can stuff with polyester fiberfill. Once stuffed, sew the opening closed.

squam
art workshops

PERMISSION TO CREATE

Every year, more than twenty-seven of the United States, along with parts of Canada, Mexico, Japan, Ireland, Qatar, Switzerland, and the United Kingdom are regularly represented amongst attendees of Squam Art Workshops (SAW). It is an art gathering that has been described by students, teachers, and staff alike as "magical," "transformative," and "inspiring."

Once you arrive, vintage cabins are where you'll settle into, as you meet your roommate and cabin mates—all of whom have traveled great distances to embark on a creative journey where for a few days, they give themselves permission to splatter paint onto paper, turn roving into yarn, learn new chords on the ukulele, stay up until the wee hours, and perhaps decide to eat ice cream for breakfast.

When faced with this type of unbridled freedom, people are able to "observe the limitations and restrictions that we place on ourselves in some of the most innocuous ways," notes SAW Founder and Director, Elizabeth MacCrellish. "By dipping our toes in the water, so to speak, and giving ourselves this type of permission and freedom, we begin moving out of culturally imposed confinements and shifting into a larger, more expansive space where we create the rules we wish to live by."

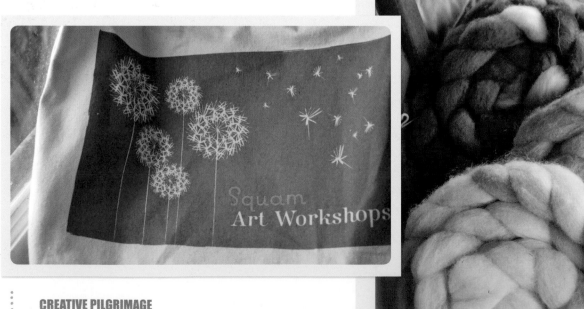

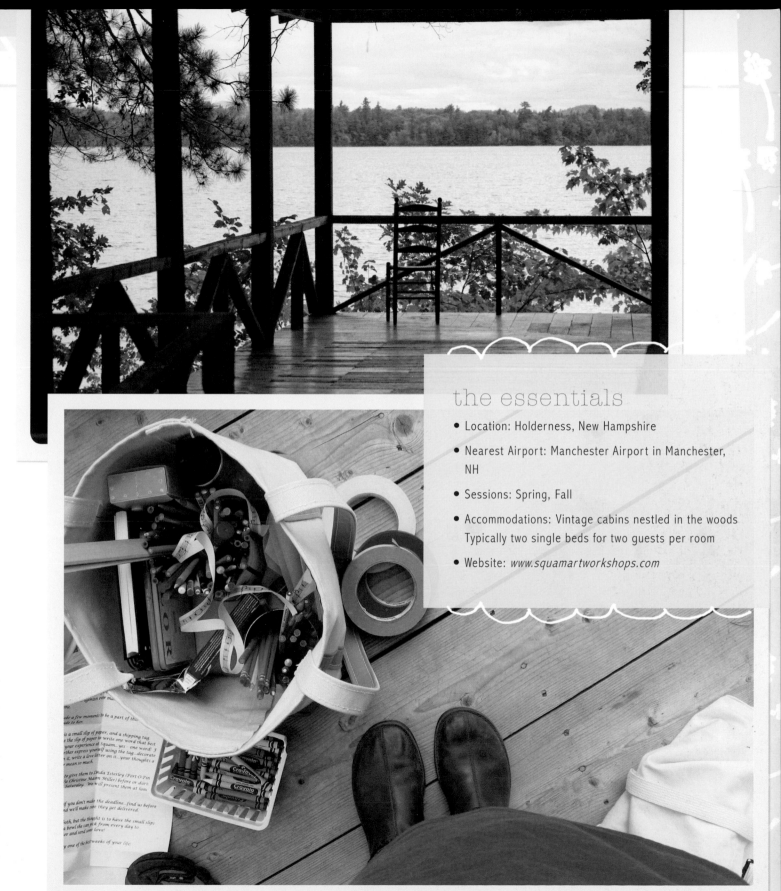

the essentials

- Location: Holderness, New Hampshire
- Nearest Airport: Manchester Airport in Manchester, NH
- Sessions: Spring, Fall
- Accommodations: Vintage cabins nestled in the woods Typically two single beds for two guests per room
- Website: *www.squamartworkshops.com*

squam
art workshops

STENCILS, FINGERLESS GLOVES, PAINTS & MORE

The Spring Session focuses on fibers and textiles, where instructors have included Jared Flood, Stephanie Pearl-McPhee, Maya Donenfeld, Denny McMillan, Charlotte Lyons, Rebecca Ringquist, and many more. From stencil printing to designing a skirt pattern to knitting fingerless gloves, attendees get steeped in the colors, textures, and warmth offered by the talented faculty.

The Fall Session focuses on Visual Arts and Writing, where instructors have included Sarah Ahearn Bellemare, Mary Beth Shaw, Judy Wise, Flora Bowley, Jonatha Brooke, and more. From book construction to collage to painting to songwriting, and more, attendees not only walk away with new technical skills but also build new relationships that tie them to a wonderfully creative community.

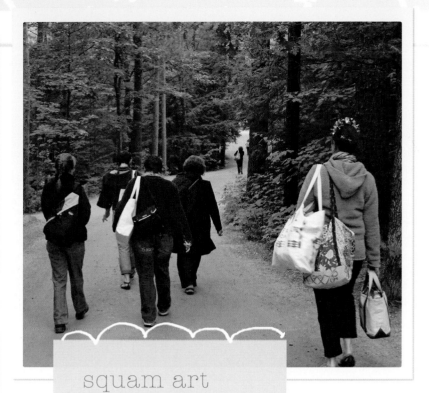

CREATIVE TRIBE

Elizabeth is very aware that as people gather to create, they also gather to share stories with one another. Sometimes, those stories are of struggle and discouragement as well as stories of hopes and dreams. "We all need the support and encouragement," she says, and explains that "these friendships and connections can sustain us long after the weekend is over. We realize that not only are we not alone, we are part of a most wonderful tribe."

"I like to think that the essential gift of SAW is the opportunity to reconnect with your best self. And that once the unique passions and life experience that define who you really are come to the fore, that you are able to truly see what a light in the world you are."

squam art workshop is ...

a place for people to gather and indulge in the fun of being creative without judgement. The mission of SAW is to promote love, light, and the exhilaration of creativity.

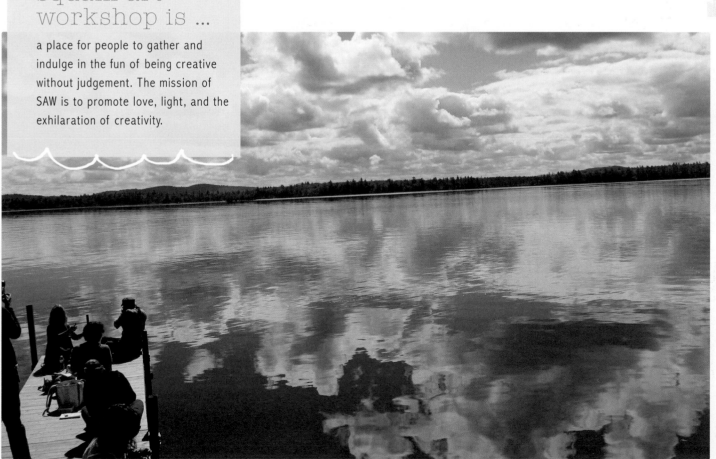

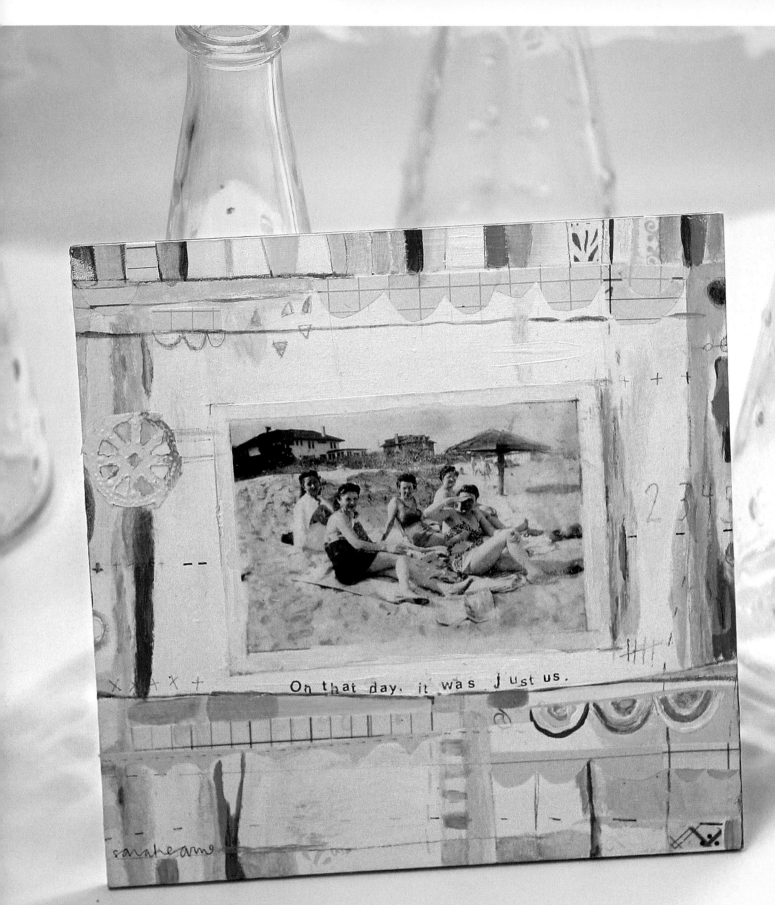

On that day, it was just us.

sarahearne

SARAH AHEARN BELLEMARE

"It's always ourselves we find in the sea ..."

—E. E. Cummings

FINDING HER WAY

Sarah Ahearn Bellemare's path to painting began in a rather unexpected way ... when the graduate student who was teaching the "Drawing for Non-Majors" class she had enrolled in noticed that she was holding her pencil like a paintbrush. Instead of trying to correct her, the teacher handed Sarah a brush and allowed her to spend the rest of the semester splattering paint over giant canvases. "And the rest, as they say, is history," she says. "I feel so lucky that she helped me along my creative path by noticing that I needed to 'break the rules' and try out something that went against the grain and plan in her own classroom."

THE CREATIVE SPARK

Sarah's mixed-media art is all about fun and personal expression, combining found images, old book pages, vintage map pieces, and a healthy coat of paint. This fun can be found in her first book, titled *Painted Pages*. When she's creating in her own studio, she likes to have everything that she could possibly need available and in sight, so she takes the same approach with her students. Says Sarah: "Sometimes I'll put out a pile of torn up, old maps to see if it will spark someone's creativity, and sure enough, it's those random materials that will be the starting point for someone's masterpiece."

POINT OF VIEW
Sarah's keys to inspired and authentic living

- Whether I'm teaching, being a student, or just living life, what works for me is having an open and flexible program that allows me to do my own thing.

- I'm constantly collecting ideas and inspiration in my sketchbook. This helps me to hang on to those wonderful creative sparks that come randomly throughout the day.

- Cleaning and organizing my studio is a big part of my artistic process. I make huge messes when I work, and if I don't tidy up before I start a new project, I have a very hard time staying focused and productive.

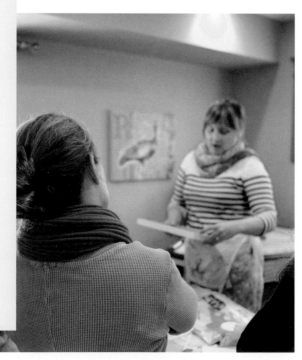

LEARNING BY DOING

Sarah believes that her role as a teacher is to act as a "safety net"—to create an environment in which her students feel free to try new techniques and materials without worrying about the outcome. Since everyone has a different way of learning, Sarah makes an effort to incorporate different teaching styles into every workshop so that everyone feels comfortable and included in the process.

She's discovered that the best way for her to learn is to jump right in and get her hands dirty, so she always tries to teach by doing instead of by lecturing. Sarah begins her classes by providing an overview of the day's lessons, and then engages her students by giving examples of the techniques in action … without focusing too heavily on the end result. "The final outcome of a project may look completely different from another student's, but that's the beauty of art," says Sarah. "We're all doing it our own way."

she laughs

I brought my daughter to Squam for the first time when she was three months old, and it was so cold that I had her sleep with me in my bed. She was warm and cozy but I was too scared to sleep, which left me a bit delirious for my morning class. As I settled in and started teaching, I caught myself swaying side to side as if I was still wearing my baby!

GETTING COMFORTABLE

Despite the unconventional approach that had been taken by her mentor, Sarah found herself sticking to a more traditional curriculum when she took her first teaching job ... at least at first. Being fresh out of college and having a classroom full of high school students to keep in line, she initially focused on gaining their respect. Says Sarah: "As I became more comfortable, I threw out all of the lessons I was supposed to teach the 'old-fashioned way' and created my own."

Now, the first rule that Sarah announces when students enter one of her classes is that there is no "wrong" in art, especially in a workshop setting. She even borrows from some of the activities she developed during her early days of teaching to help participants loosen up and have fun with the painting process. "Some of my students arrive at Squam not knowing anyone and trying completely new things in a foreign place ... they are really out of their comfort zones," she says. "But from that uncomfortable place comes so much learning. Witnessing this blossoming of beauty and dreams is so very inspiring."

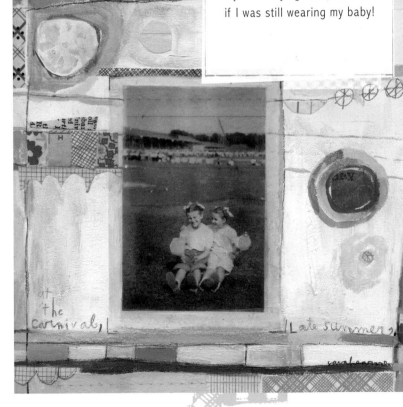

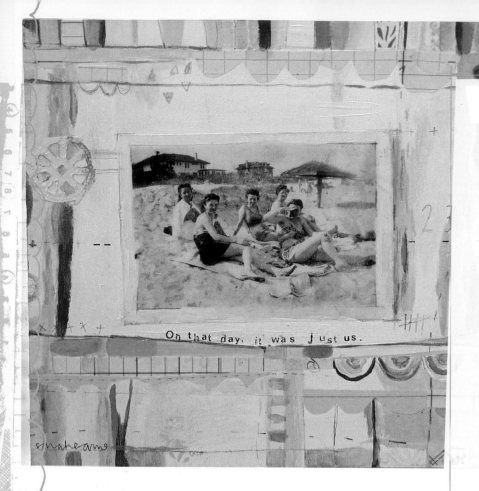

On that day, it was just us.

CREATING WITH SARAH:
BY THE SEA COLLAGE

A simple image transfer technique transforms a favorite black-and-white photograph into a transparent collage element for this piece. Vibrant acrylic paints and vintage papers are then layered to create a mixed-media base for the transferred image.

what you'll need

- color laser copies of black-and-white photograph
- sketchbook or blank sheets of paper
- basic sketching and journaling supplies
- clear contact paper (shelf and drawer liner found in kitchen aisle in grocery store)
- burnishing tool
- bowl of warm water
- wood panel or other base surface such as canvas or mat board
- acrylic paints
- small paintbrushes
- vintage papers
- scissors
- gel medium (with a UV filter)
- rub-on letters

techniques you'll learn

- contact paper image transfer
- mixed-media collage
- painting

one

Select a black-and-white photograph to use as the focal point of your collage. Make color laser copies of the image on regular paper, including a few extra copies to use while you practice the image transfer technique.

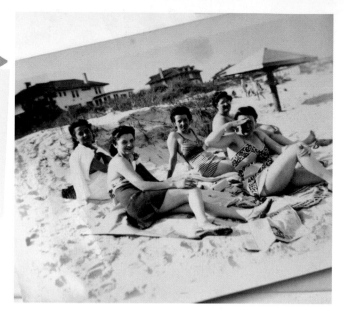

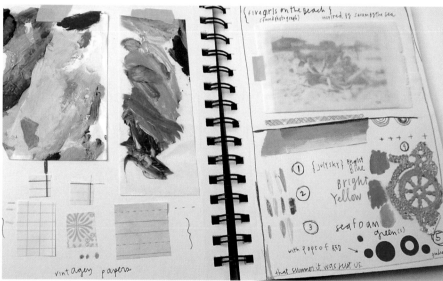

two

Explore color palettes and write down ideas for your project in a sketchbook or on blank sheets of paper. This will not only help you plan the arrangement of your final piece, but will also give you a chance to warm up before painting.

three

Create the image transfer by covering the laser photocopy with a layer of clear contact paper, applying the adhesive side directly to the image. Remove bubbles and fuse the layers together by rubbing with a burnishing tool.

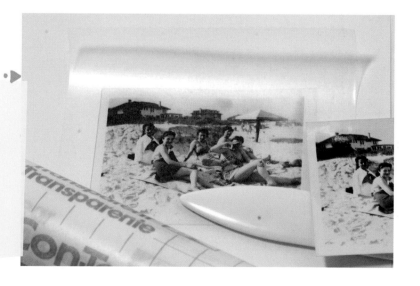

four

Soak the image adhered onto contact paper in warm water for a few minutes.

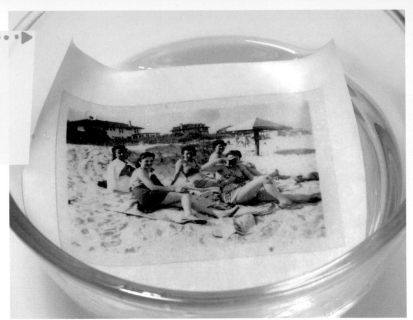

five

Gently rub the paper off of the transfer using your fingers. Once all of the paper has been removed, pull the transfer out of the water and allow to dry.

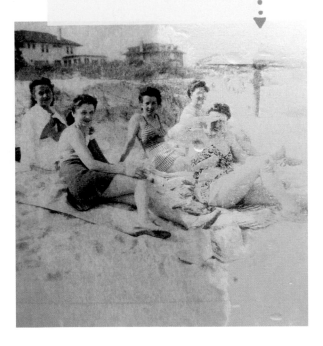

six

Trace the areas of the photograph where you would like to add color onto your base surface, using the image transfer as a guide. Add touches of acrylic paints with small paintbrushes to accent the area where the image transfer will be placed and to decorate the edges of the base surface. Allow to dry thoroughly.

create with Sarah at:

- Squam Art Workshops (*www.squamartworkshops.com*)

seven

Cut and adhere pieces of vintage paper and add additional acrylic paint accents to fill in the blank areas of the base surface.

eight

Adhere the image transfer to the base surface by applying a layer of clear gel medium with a paintbrush.

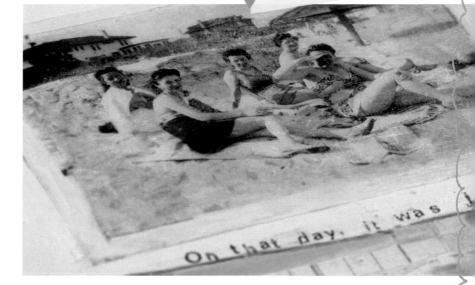

nine

Add rub-on letters below the image with a pencil.

ideas & variations

- Play with the placement of the image transfer and the collage elements prior to gluing them down with gel medium.

- Experiment with different color combinations to achieve unexpected and unique effects.

- Incorporate family photographs into this project as a fun way to give new life to forgotten images.

- Use pops of accent colors to enhance the image transfer, but avoid filling it in completely.

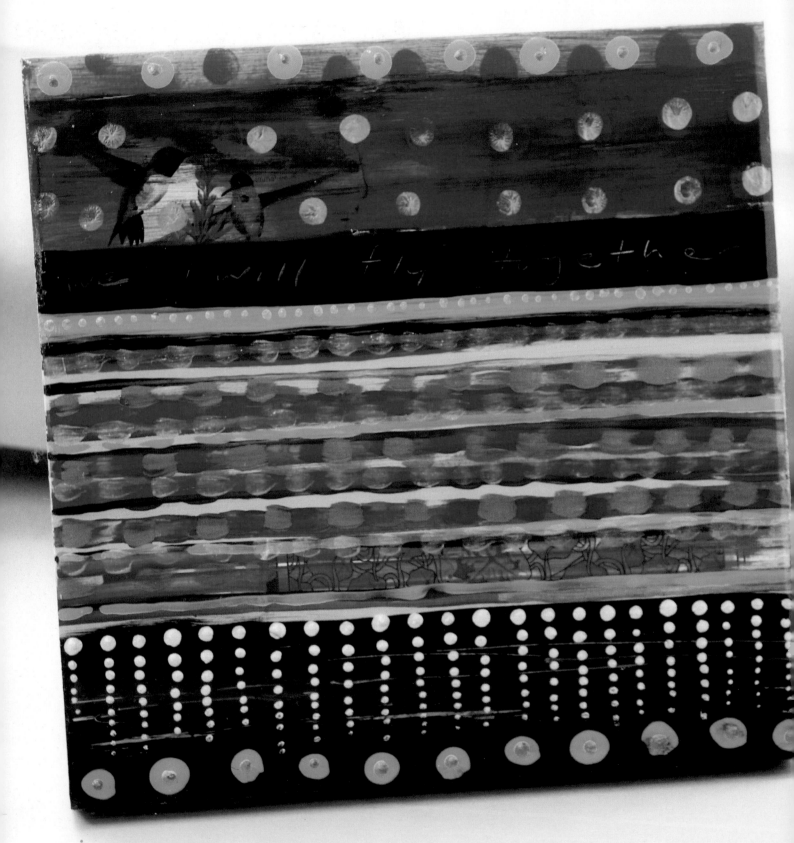

FLORA BOWLEY

UPLIFTED & CONNECTED

An avid yoga enthusiast, Flora Bowley credits her yoga instructor, Lisa Mae Osborn, as being the muse for her own teaching style. Flora describes her as possessing the "graceful and rare" combination of being "extremely knowledgeable, super down-to-earth, and really funny," which she uses to create an environment that instills positivity and joy into all who attend. Says Flora: "Her classes are infused with music, poetry, and a general sense of celebration that I find inspiring. I always leave class feeling uplifted and connected to myself and the rest of the world."

"There came a time when the risk to remain tight in the bud was more painful than the risk it took to blossom."

—Anaïs Nin

MAGICAL MOMENTS

One look at Flora's paintings gives you an immediate sense of who she is as a person ... soulful, imaginative, free-spirited, and vibrant. In her workshops, she guides students to "let go" of expectations and embrace the journey as they discover a new, free-flowing way of painting. But, even more than that, Flora encourages them to appreciate the beauty of life. "At the end of the day, the most important way to maintain a creative life is to seek out and notice the magical moments in everyday life," she says.

Her passion for yoga and meditation is also represented in her classes, which often begin with short yoga and breathing exercises as well as an activity called a "sharing circle." In the sharing circle, students are asked to sit in a circle to discuss their present feelings—all the fears, jitters, and hopes that they have coming into the class. Talking openly about their emotions not only helps to release tension before the workshop gets started, but also provides a unique bonding experience for students. "It's proved to be a great way to diffuse their nervous energy and has resulted in everyone feeling more connected," says Flora.

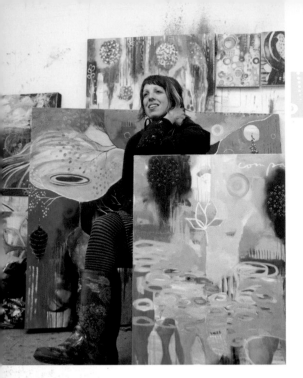

WITH WILD ABANDON

Though every class that Flora teaches is a little different, there are two elements that no workshop is without ... hot tea and music. She has found that these ingredients—as well as yoga, deep breathing exercises, and frequent creative prompts—are just as important as paintbrushes and canvases because they help students "get out of their critical thinking brains and get into the poetry of the moment." She says: "It's amazing to witness a room full of people learning something new and totally going for it with wild abandon. I'm inspired by how they dive in and how they develop their own painting language along the way."

Just as she encourages her students to let go of their expectations, Flora has learned to set aside any pre-conceived ideas that she has about the outcome of each class. "Ultimately, each student's experience is totally different depending on what they needed to experience," she says. "My role as a teacher is to support each individual artist as they embark on their own personal journey."

A CREATIVE WHIRLWIND

Like most first-time teachers, Flora approached her debut class at Squam Art Workshops with a mixture of excitement and nervousness. But instead of letting her nerves overwhelm her, Flora put her energy into developing a curriculum that was as much about creating a comfortable environment for herself and her students, as it was about learning techniques. "That day was a whirlwind of demos, painting, stretching, reflecting, getting stuck, getting unstuck, and learning a whole new approach to painting, and to life," says Flora. "By the end, everyone in the class was pretty amazed by their big, colorful creations—and for me, a new profession was found."

In addition to painting techniques, it's Flora's hope that students who take her workshops leave with lessons that they can carry with them into their day-to-day lives. "There is no right or wrong in art ... it's about setting aside your ideas of 'perfection' and allowing your unique voice to shine through. The creative process is a larger metaphor for living authentically, being bold, and finding joy along the way."

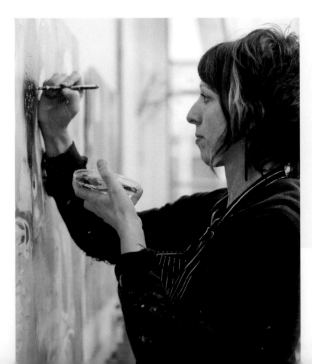

POINT OF VIEW
Flora's keys to inspired and authentic living

- Being committed to doing what I love and being attentive to nurturing my passions leads me to live an authentic life.

- Instead of focusing on the past or the future, I aim to stay present and live in the now. I try to avoid feelings of regret so that I can put my energy into finding joy in my daily life.

- I am continually refining my way of living. I examine what is working in my life and what I need to let go of, so that I can actively make choices about how I spend my time.

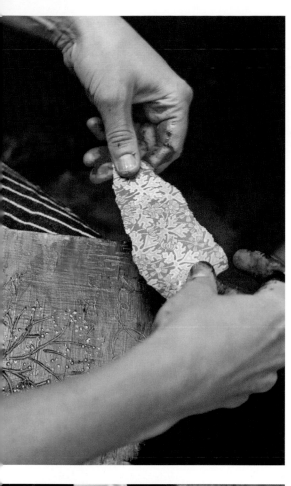

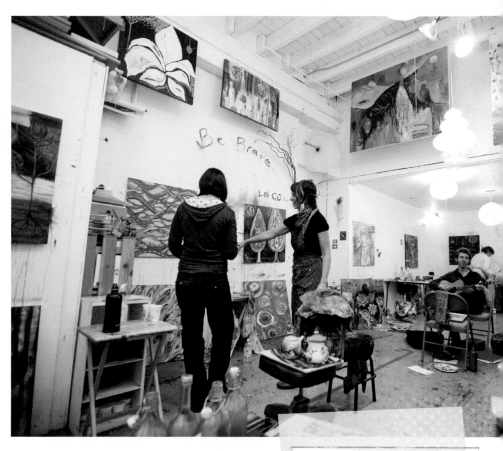

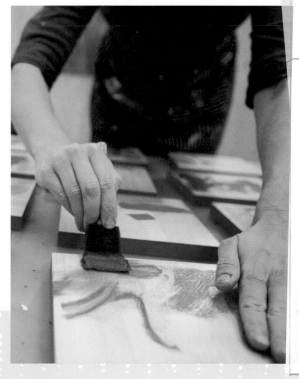

she laughs

We often take "movement breaks" in my workshops, and I encourage my students to shake their whole bodies and release tension through their voices at the same time. At a recent class, one particularly outgoing student got really into it, and her exuberance became contagious. Before long, the whole group was giggling, shaking, and dancing around the room.

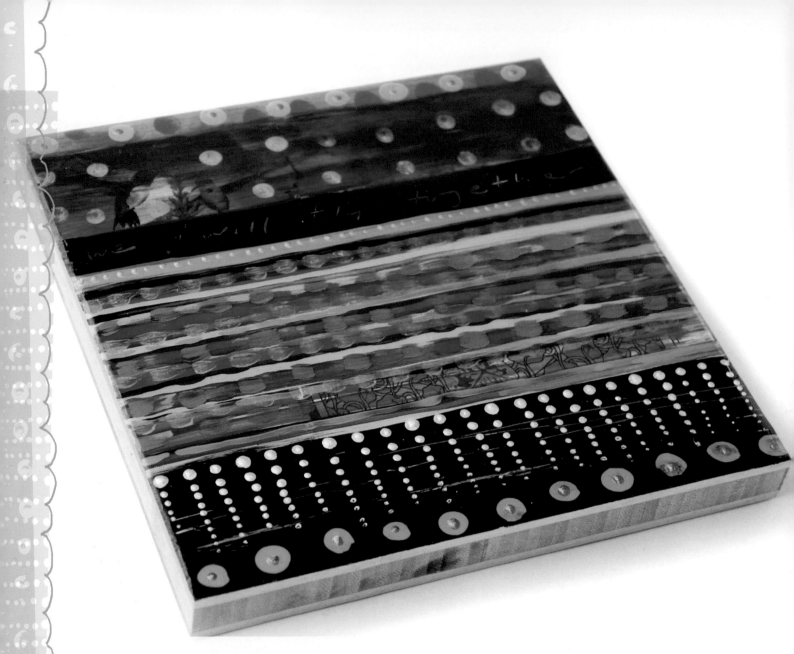

CREATING WITH FLORA:
LAYERED MINI PAINTINGS

Intricate details make a big impact on these small-scale paintings, which use layered acrylic paints, bits of paper, and stamped elements to create depth and dimension. Applying a clear, glass-like layer of resin over the finished piece is an easy yet effective way to make the colors in the piece pop.

what you'll need

- 1 piece of cut and sanded bamboo plywood, 8 x 8 inches (20.32 x 20.32 cm)
- drill
- blue painter's tape
- Golden GAC 100
- fluid and heavy body acrylic paints (including translucent paints)
- acrylic inks
- foam brushes
- paintbrushes
- spray bottle of water
- acrylic glazing medium
- assorted paper ephemera
- stylus (or other mark-making utensil)
- assorted stamps and stencils
- resin

techniques you'll learn

- mixed-media collage
- applying a resin overlay
- painting

one

Drill a hole at the back of the plywood for hanging. Apply blue painter's tape or masking tape around the edges of the board to keep them clean.

two

Apply two layers of Golden GAC 100 to completely cover the bamboo square. Bamboo plywood contains glue that will leak into the painting and discolor it. This step of applying the GAC 100 will help to seal the wood and disallow the wood's glue to contaminate the paints.

three

Apply swatches of color with acrylic inks and paints. Spritz water onto the paint with a spray bottle while the paint is still wet.

four

Adhere small pieces of assorted paper ephemera to the piece with acrylic glazing medium. Once dry, add strokes of acrylic paint and etch words or patterns directly into the paint strokes with a stylus or other mark-making utensil.

create with Flora at:

- An Artful Journey (*www.anartfuljourney.com*)
- Angela Ritchie's ACE Camps (*www.ritchieacecamps.com*)
- Do What You Love Retreat (*www.dowhatyouloveforlife.com/retreat*)
- The Makerie (*www.themakerie.com*)
- Squam Art Workshops (*www.squamartworkshops.com*)
- Teahouse Studio (*www.teahouseartstudio.com*)
- Her Personal Studio (*www.florasbowley.com*)

five

Build up layers of colors and textures by adding paints and inks. Experiment with translucent acrylic paints to add sheer applications of color. Use stamps and stencils with acrylic paints to add details. Allow to dry thoroughly.

six

Pour a thin layer of resin onto the piece and let fully cure by allowing to dry overnight. Remove the tape from the edges.

ideas & variations

- Try experimenting with the size and material of your base surface.
- A wide variety of tools can be used for making marks on the collage, such as old pens, marker caps, assorted lids, sticks, fingers, and assorted brushes.
- Vary the amount and type of paper used in the collage, as well as the intensity of the paints, to achieve different looks.

the makerie

AN UNSPOKEN LANGUAGE

It's a weekend of art-making, hiking, yoga, and earth-friendly living, spent nestled in the mountains of Colorado that nourishes not only your creative self, but also your body and soul. It's called the Makerie, and it's an up-and-coming retreat that offers something for everyone.

By featuring a diverse and varied selection of workshops, in addition to outdoor activities and a vendor market filled with handmade goods, Makerie founder Ali DeJohn hopes to create a unique experience for every attendee, one that stays with them even after the retreat has ended. "It could be finally getting in touch with their creative side, or simply stepping out of a busy life to play again, or even finding a beautiful, new soul sister they never knew they had," she says.

Regardless of how the experience impacts you, Ali believes that taking time out of your life for creativity fulfills "a fundamental need." Says Ali: "When you share something as intimate as your own creativity, there is simply an unspoken language. And when we gather together with those who share the same values and general appreciation for one another's talents, a magical environment is created."

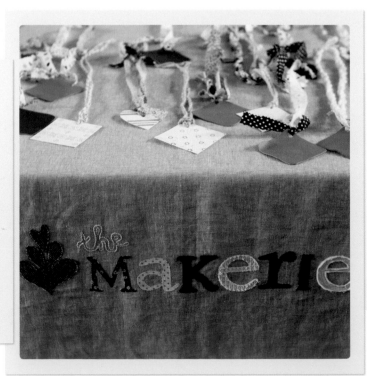

the essentials

- Location: Boulder, Colorado

- Nearest Airport: Denver International Airport in Denver, CO

- Sessions: One retreat held annually in April (and more to come!)

- Accommodations: Cozy cottages at the Colorado Chautauqua ranging in size from 1–3 bedrooms. Sleeping options vary by cottage, and include single beds, queen beds, and comfy, pull-out sofas

- Website: *www.themakerie.com*

the makerie

PAINTS, PEARLS & PURLS

Artists who are interested in engaging their mixed-media side will find a wealth of creative opportunities at the Makerie. Past workshops have featured instructors such as Flora Bowley, Lizzy House, and Alessandra Cave, teaching a unique assortment of painting, print-making, and photography skills to attendees. You can choose to spend your weekend learning to "Bloom True" or demystifying "Product Photography" to build your arts business, all under the guidance of top-notch teaching artists.

The Makerie also offers a medley of workshop options for those who prefer working in wearable art forms. Teachers including Stefanie Japel, Angie Olsgard, Katherine Sanz, and Jessica Hernandez are among the esteemed faculty from past retreats, having taught classes on everything from knitting to jewelry design to shoe-making. With an inventive curriculum that features classes like "Little Miss Mary Jane" and the "Open Knitting Lab," wearable art enthusiasts will discover an abundance of inspiring new skills at every Makerie event.

the makerie is ...

a space to learn, a place to find quiet, and a setting in which to find your inspiration. The mission of the Makerie is to lovingly nurture the creative spirit that exists within all of us.

ANOTHER WORLD

Ali's own experience at Squam Art Workshops—one that she says "truly changed [her] life"—is what led her to bring the Makerie to life. "We need to be able to take a little time and space to just be ourselves again, to honor who we are and what we love to do, and to listen to our hearts," she says.

"When we use our hands to make something, we enter another world ... a world where everything is calm, our worries melt away, and we are at peace. That's the gift that I want to share through the Makerie."

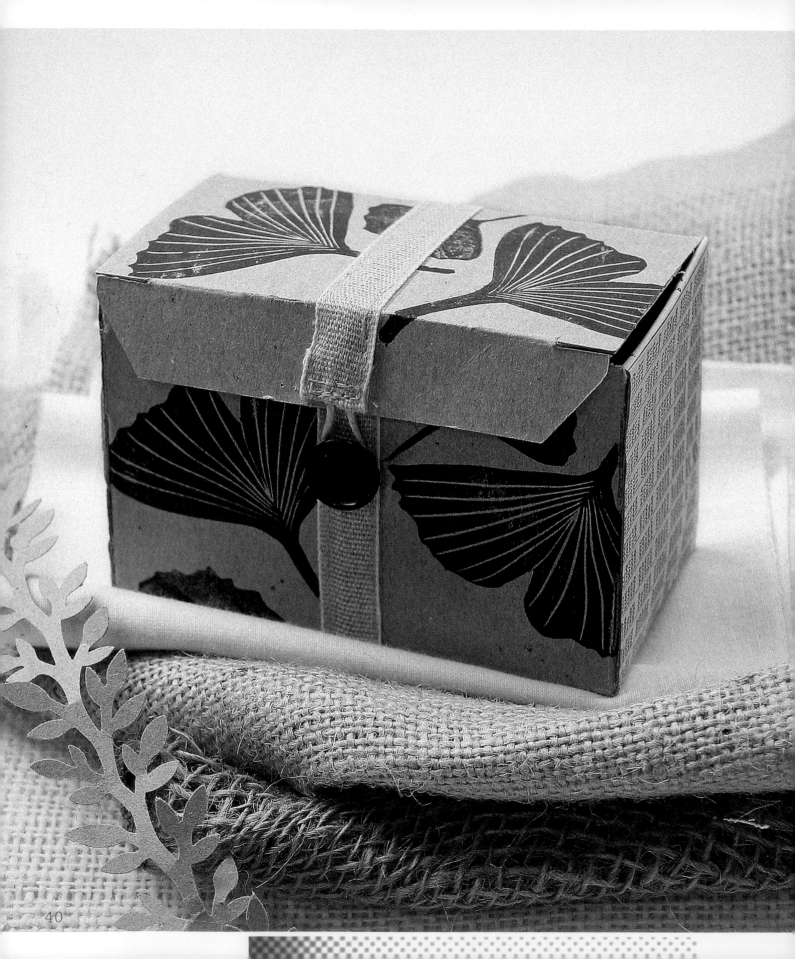

MAYA DONENFELD

CREATIVE COMPASSION

Growing up in a family of artists, builders, and inventors, Maya Donenfeld was always surrounded by creative people—the most influential of which was her grandmother. As a nursery school teacher, she had a knack for making those around her feel noticed, unique, and valuable, and imparted on Maya the importance of kindness. She says: "She taught me how to be compassionate for where an individual might be in the moment, and the ability to see their amazing potential. I try to carry her wisdom into my own life, as well as into the workshops I lead."

A SMALL FOOTPRINT

Maya's art is thoughtfully crafted from a mix of vintage, modern, recycled, and organic supplies with a single goal in mind—to make sustainable creations that "leave a small footprint, but make a big design statement." Her go-to material is burlap that she repurposes from used coffee sacks, but her creative nature leads her to turn practically any recycled material into art. Between sewing, painting, and taking photographs, Maya also shares recipes, tutorials, and scenes from her garden on her blog, maya*made.

"Being creative is not so much the desire to do something as the listening to that which wants to be done: the dictation of the materials."

—Anni Albers

Her love for recycled materials and earth-friendly design practices is also highlighted in her workshops, which provide attendees with innovative ideas for making the most of the supplies they already own. Says Maya: "Techniques and trends come and go, so I teach people to use what they have on-hand—from everyday objects to their own inherent abilities. To be able to share my passion for transforming humble materials into objects of beauty with others ... well, it doesn't get any better than that!"

CREATING A SAFE ENVIRONMENT

For Maya, the key to teaching a successful class is to first and foremost, create a safe environment. This is why she starts her classes with an "opening circle" where she invites students to embrace her intent for the day, which is an intent of discovery. By focusing on discovery, Maya hopes that students are able to be gentle on themselves as they approach new materials and new techniques.

Flexibility is also an important component of Maya's classes. "I have a fairly defined outline for each workshop, but flexibility is built in so that we may flow with the energy that each new group generates," she says. "I also understand that everyone has a unique approach to their creative process and try to create opportunities for little bits of one-on-one time to establish what those needs might be."

she laughs

On the first day of a class I was teaching at Squam Art Workshops, I noticed that one of the participants was late. I feared that she may have gotten lost on the forest trails, so I decided to venture out to see if I could spot her. I quickly saw her beaming face through the trees. Out of breath, she gasped and giggled, saying "I was lost in the woods with my sewing machine … when will that ever happen again?" We couldn't stop laughing as we made our way back to the group.

POINT OF VIEW

- Knowing myself deeply and being aware of my strengths and weaknesses helps me to stay grounded in authenticity.

- I try to make something every single day. The act of creating generates new and exciting ideas for me.

- When I find myself in the midst of a busy day, I like to take a minute to just breathe and say "hello" to the present moment. Stop. Breathe. Hello. This takes practice, but I have found that it increases my ability to focus on what is real.

SETTING THE TONE

Maya spent many years working in childhood education—an environment where art was woven into the classroom experience quite seamlessly—before she taught her first creative workshop to adults. She admits that she was "more than a little anxious" about her debut workshop, but she found that setting the tone with a welcoming environment and heartfelt introduction helped everyone feel at ease from the start. "When you step into an unfamiliar setting where the expectations are high, you can feel quite vulnerable," says Maya. "Beginning with acceptance and warmth has the potential to lead to exciting breakthroughs ... or, at the very least, a few lovely hours creating together."

"I share how to reinvent everyday materials with thread and glue; I teach how to print on fabric," says Maya. "But I know there is more to what happens in every class than cutting burlap and mixing colors. I am honored to be entrusted with such a responsibility."

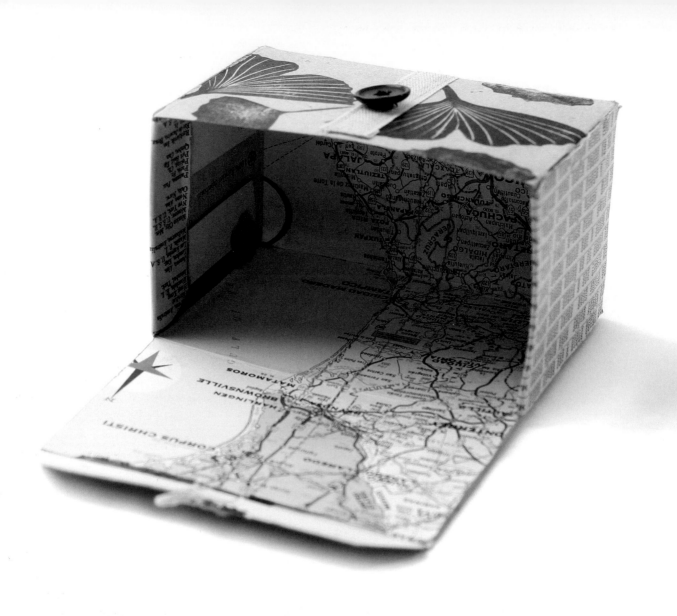

CREATING WITH MAYA:
EXTRAORDINARY FOUND

In this project, you will learn how to deconstruct almost
any box from your everyday life, and use straightforward
methods to decorate its interior and exterior with found
papers. Rubber stamping and simple stitching techniques
are used to elevate the box into a work of art.

what you'll need

- small recycled box (such as a cardboard tea box)
- paper ephemera (such as maps and vintage book pages)
- ruler
- sharp craft knife
- white glue
- brayer (or bone folder)
- rubber stamp
- black inkpad
- twill tape
- hemp twine
- sewing machine
- button
- handsewing needle and thread
- glue gun
- paper clips

techniques you'll learn

- altering recycled materials
- assembling a box
- surface decoration

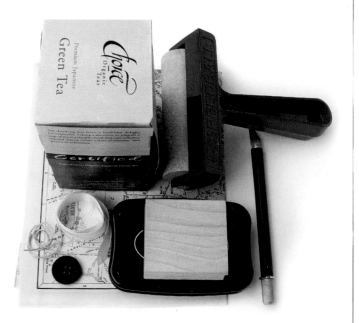

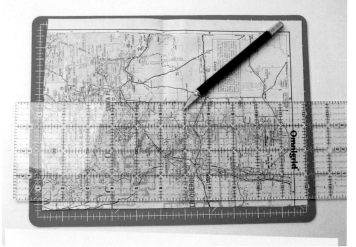

one

Take apart a small, recycled cardboard box by carefully separating all adhered surfaces. Lay the box flat on a work surface and place a sheet of paper ephemera on top. Use the flat box as a template, along with a ruler and sharp craft knife, to cut the paper to cover the original exterior of the box.

two

Adhere the cut paper to the original exterior of the box with glue. Use a brayer or bone folder to smooth out any wrinkles that appear when folded at the creases. Allow to thoroughly dry.

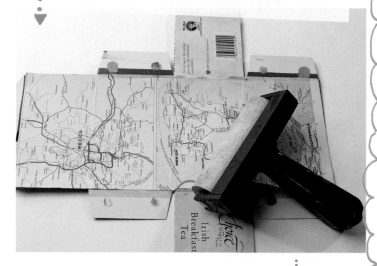

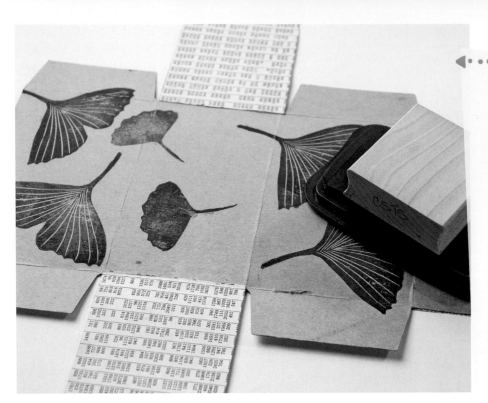

three

Adhere side flaps (and any other spot that may have rough spots from where it was originally glued together) with white glue and paper ephemera that is cut to size. Use a brayer or bone folder to smooth out any wrinkles. Allow to dry. Fill the rest of the space by rubber stamping a simple image or two with a black inkpad.

four

Cut a piece of twill tape that is long enough to wrap around the box vertically and machine stitch it to the center of the exterior. Attach a loop of hemp twine to the top edge of the twill tape. If you do not have a sewing machine, you can adhere the twill tape to the box with white glue.

create with Maya at:

- Red Barn Studio (*www.mayamade.com*)
- Squam Art Workshops (*www.squamartworkshops.com*)

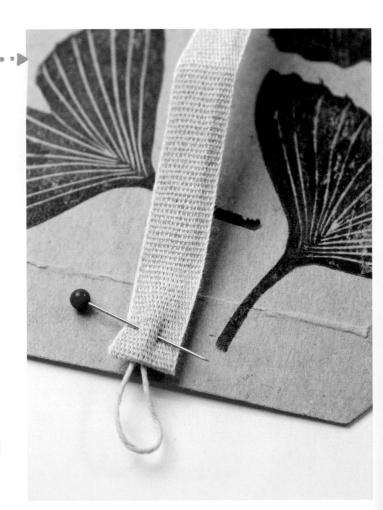

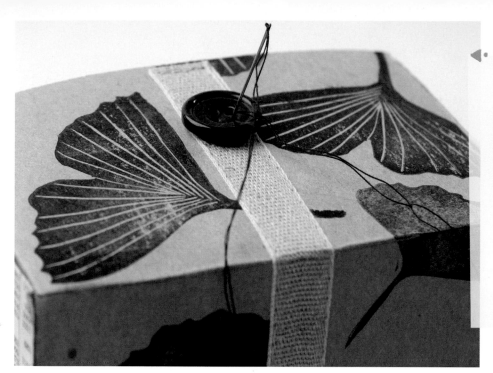

five

Sew a button to the lower portion of the box with a handsewing needle and thread. Make sure that all of your stitches are locked in place with a backstitch.

six

Glue the sides of the box together with a hot glue gun, ensuring that the new exterior is facing out. Attach paper clips to align all parts while drying. Work safely but swiftly with the hot glue gun. The faster you work, the less bulky your glued areas will be.

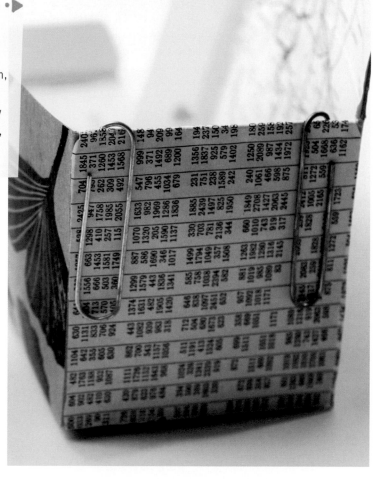

ideas & variations

• The process of deconstructing, embellishing, and rebuilding can be applied to any box in your pantry.

• Experiment with different closure styles and surface decorations to vary the look of your finished box.

• Try creating a box where you consider each individual side as its own unique canvas.

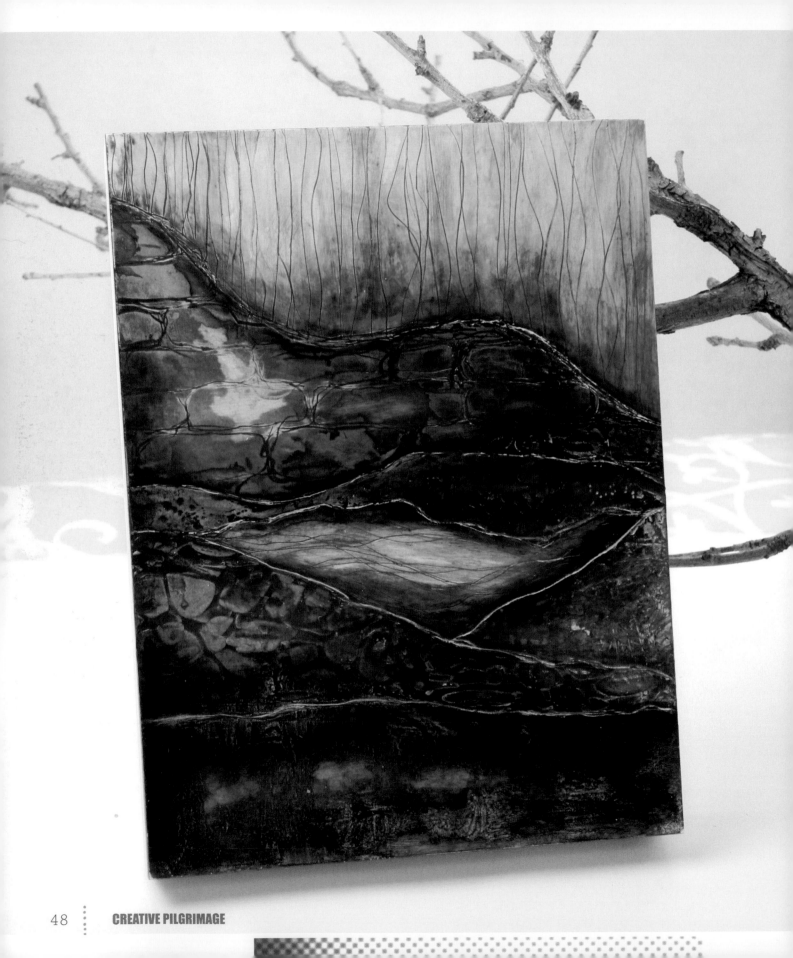

MARY BETH SHAW

"I am not going to die, I am going home like a shooting star."
— Sojourner Truth

FINDING FREEDOM

Mary Beth Shaw's life has been filled with many wonderful and generous teachers. They have shared their processes with her, and taught her how to be a "better, more informed critic" of her own work. However, Mary Beth believes that her greatest lessons have come from her mistakes. "That is when I really let go," she says. "When I'm already facing failure, I find the freedom to try anything."

LAYER UPON LAYER

In her own art, Mary Beth is all about layering and discovery. Her paintings, collages, and multi-dimensional works are the product of collage elements sandwiched over and under paint, texture paste, pastel, graphite, fabric, and ink. She intentionally distresses her pieces with sandpaper, selectively peeling away some layers to expose others. "I focus on the physical and intuitive act of making each piece, and the final product becomes a record of that activity," she says.

In her workshops, she layers technical education with experiential learning to create lessons that are just as much celebrations of the creative process as they are about developing art-making skills. Says Mary Beth: "The people who come to workshops are adventurers; they are my heroes and heroines because of their courage to open themselves up to new things."

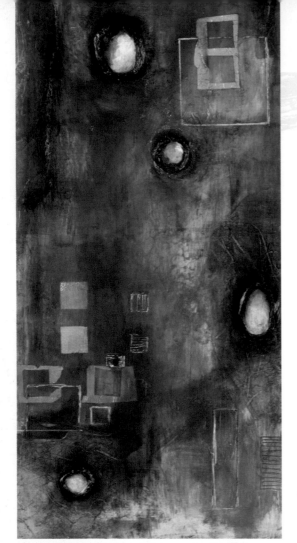

LAUGHING, PLAYING & HAVING FUN

When it comes to teaching, Mary Beth has one goal ... to make sure that each and every student feels comfortable enough to be themselves. "Although I teach specific techniques and processes, often in a project format, I want each person to be able to honor their own voice within the context of my teaching," says Mary Beth. "I want my students to laugh and play and have fun. I strive to keep it free, as I don't want my students to tense up, or feel inhibited or limited in any way."

Mary Beth has come to realize that in each workshop, she does just as much learning as she does teaching. Her workshop attendees keep her in-the-know about the latest and greatest artistic gadgets, and show her their favorite ways of using them. But in a more profound way, Mary Beth's students have taught her about herself. She says: "Through my teaching, I think I have found myself, and my students have been instrumental in this as they have encouraged me and been unbelievably supportive."

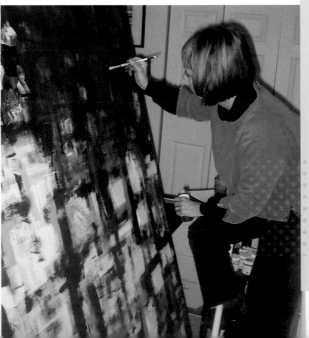

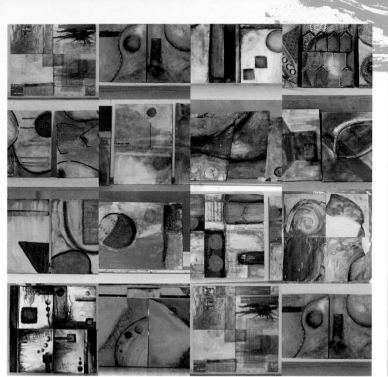

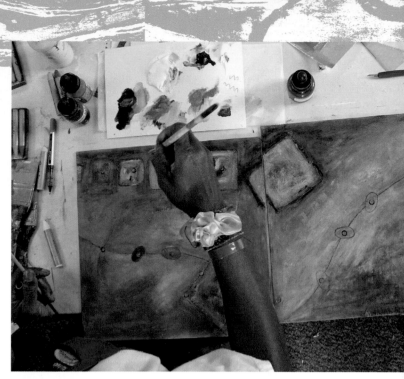

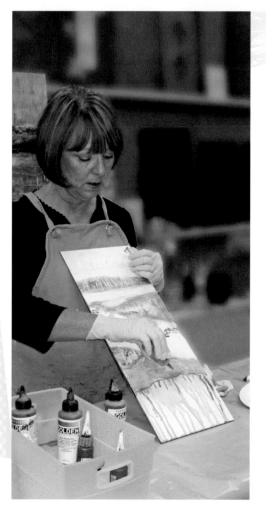

THE BIG TIME

Mary Beth's first opportunity to teach a "big time" art class was at a packed, 24-student workshop at Artfest. As a self-professed "stickler for detail," Mary Beth diligently organized every aspect—from the art supplies to her handout materials to the perfect workshop playlist—and by the time the class started, she felt strong, confident, and prepared. She says: "The class played out beautifully; my students were so receptive and gracious that I relaxed into myself and relished each and every moment. I was incredibly humbled and deeply touched by the entire experience."

Her transition into the world of teaching the arts professionally has come very naturally for Mary Beth, but she still finds herself learning something new with every class. "What I didn't expect was the connection I'd feel, to the people, the places, the moments," she says. "It is simply overwhelming ... the emotion I feel from the experience of bonding with so many like-minded souls."

CREATING WITH MARY BETH:
STRATALICIOUS MIXED-MEDIA PAINTING

In the spirit of Mary Beth's love of layering, this painted project explores the use of texture medium and color to simulate natural and man-made rock formations. The techniques used to create this piece are easily adapted to a variety of substrates, and can lend depth to all types of mixed-media projects.

what you'll need

- clayboard, 9 x 12 inches (22.86 x 30.48 cm)
- graphite pencil
- spray bottle filled with water
- sharp craft knife (or other carving tools)
- Wood Icing Textura Paste
 (or other acrylic texture mediums)
- mylar stencils
- fine-grit sandpaper
- paintbrushes
- fluid acrylic paints and acrylic inks
- Polymer Varnish Gloss by Golden (with UVLS)
- 2 pieces of ¾ x 1½ inches (1.9 x 3.81 cm) lumber,
 each 12 inches (30.48 cm)
- 2 pieces of ¾ x 1½ inches (1.9 x 3.81 cm) lumber,
 each 7½ inches (19 cm)
- wood glue

techniques you'll learn

- surface texturing and color blending
- carving

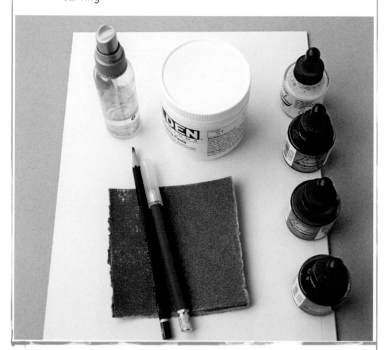

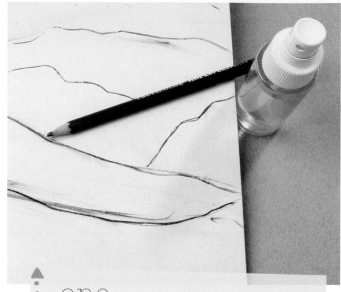

one

Start by drawing a rough sketch of geological stratum onto your clayboard using a graphite pencil. Lightly spray your pencil lines with water to blur the edges slightly.

two

Once the water has dried, use carving tools to carve into sections of the clayboard to simulate layers of rock.

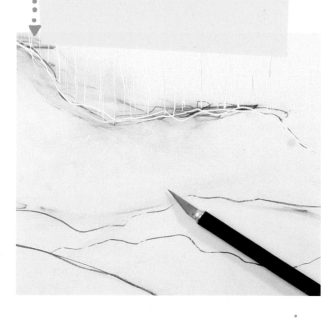

three

Apply Wood Icing Textura Paste to develop layers of texture. Use mylar stencils with the paste to create patterns. Selectively leave some areas free of texture to enhance the feeling of depth in the piece. Allow to dry.

four

Lightly sand the textured portions with fine-grit sandpaper.

five

Use paintbrushes to apply layers of fluid acrylic paints and acrylic inks to the textured and non-textured portions of the Clayboard.

create with Mary Beth at:

- Adventures in Italy (*www.adventuresinitaly.net*)
- Artfest (*www.teeshaslandofodd.com/artfest/info.html*)
- Artinfusio
 (*www.sweetsistergina.typepad.com/artinfusio*)
- Art Unraveled (*www.artunraveled.com*)
- Squam Art Workshops (*www.squamartworkshops.com*)
- Valley Ridge Art Studio
 (*www.valleyridgeartstudio.com*)

six

Continue steps three through five as you build layers of texture medium and color until you are satisfied with your piece. Let dry.

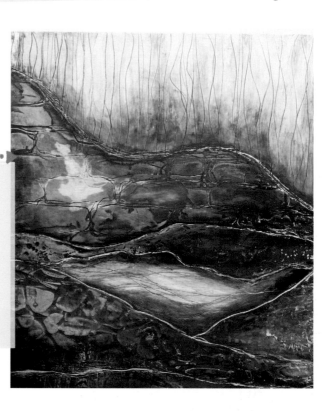

eight

Assemble a cradle for the clayboard by affixing the pieces of cut lumber onto the back side with wood glue. Allow to dry, per the manufacturer's instructions. Most hardware stores will cut lumber to your specifications at the time of purchase.

seven

Apply Polymer Varnish Gloss to the entire piece and let dry.

ideas & variations

- These techniques can be applied to any sturdy substrate, such as picture frames, cigar boxes, or even interior walls.

- Use variations of similar hues to make your textured sections feel more rock-like.

- If you find that your texture is not coming out as expected, simply apply additional texture medium to change the composition of your piece.

artfest

SCENE & BE SEEN

Once a year, an out-of-commission military base is transformed into a thriving creative hub, where hundreds gather to take workshops from some of the biggest names in the art world, to break bread with fellow artists, and to create deep, personal connections. This inspiring event is known as Artfest, and it's one of the largest, most active art retreats in the world.

From the moment your plane touches down in Seattle to the scenic ferry ride over to Fort Worden, from the journaling beach party and bonfire to the alternative artist's marketplace, every minute of your Artfest

adventure is a celebration of the creative spirit. Some events have "crazy, go-go-go" schedules while others are slower paced, but each one has its own unique energy that keeps participants coming back year after year.

In this age of sitting behind a computer screen for much of the day, and then a television screen for much of the night, sometimes we need to be reminded of "the primal necessity of human interaction," observes Artfest Founder Teesha Moore. "When these groups of like-minded people get together, a renewed excitement about life ensues as they begin to explore ideas and projects that they can share with one another. They tell their stories, and they realize that they are part of a larger collective of individuals."

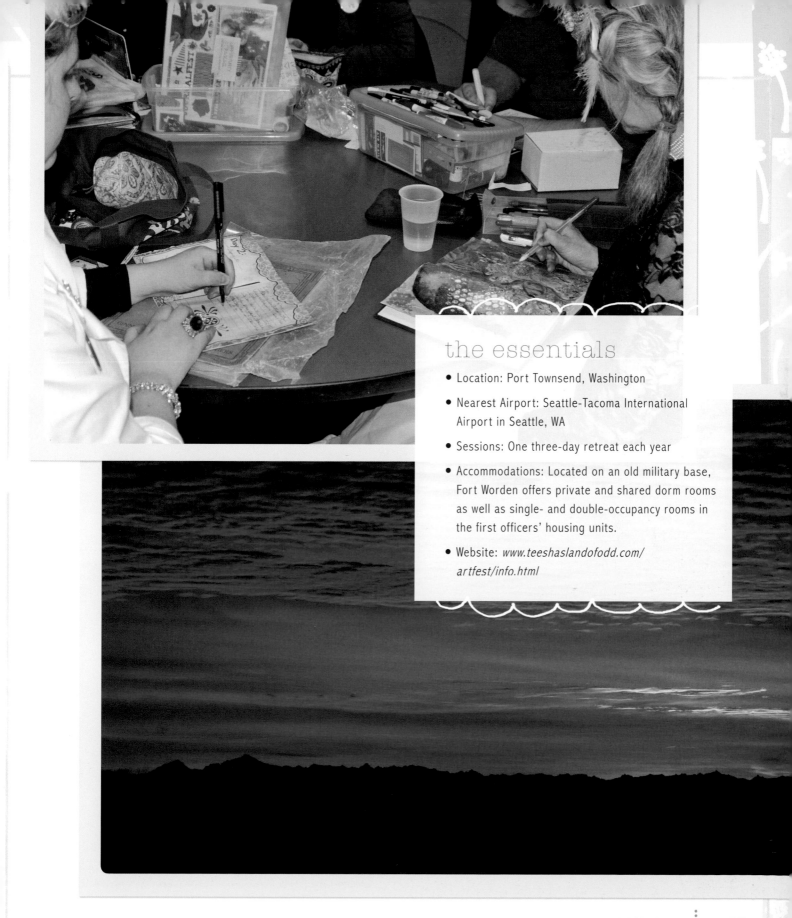

the essentials

- Location: Port Townsend, Washington

- Nearest Airport: Seattle-Tacoma International Airport in Seattle, WA

- Sessions: One three-day retreat each year

- Accommodations: Located on an old military base, Fort Worden offers private and shared dorm rooms as well as single- and double-occupancy rooms in the first officers' housing units.

- Website: *www.teeshaslandofodd.com/ artfest/info.html*

artfest

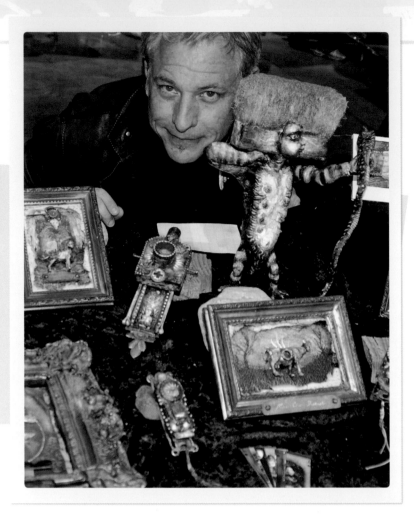

ARTFEST 2008

FROM SILLY TO STRANGE

Mixed-media artists, paper-crafters, and journaling enthusiasts will find a wide selection of classes at Artfest, with past instructors including LK Ludwig, Lynne Perrella, Lisa Engelbrecht, Mary Beth Shaw, and many more. With class titles such as "Outside the Box," "The Art of Silliness," and "Painting Without Fear" among the more than 90 workshops offered in a single weekend, attendees are sure to find topics that will both challenge and enlighten.

Devotees of fabric, fiber, jewelry-making, doll-making, and sculpture will find a myriad of options at Artfest, with past instructors including Michael deMeng, Laurie Mika, Nina Bagley, Karen Michel, and many more. Whether you choose to learn the art of "Strange Angels," "Creative Mojo Shields," or a "Necklace of Affirmation," you will be treated to a truly unique and creative experience under the guidance of immensely talented faculty members.

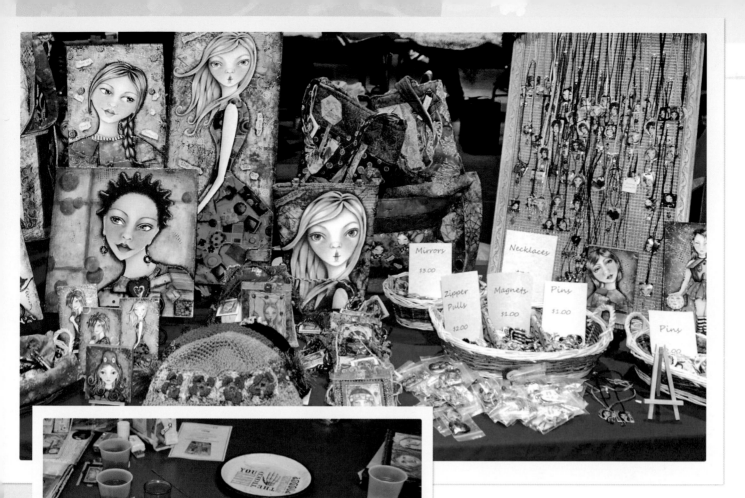

Mirrors
$3.00

Necklaces

Zipper
Pulls
$2.00

Magnets
$1.00

Pins
$1.00

Pins

CREATIVE EXPOSURE

Teesha believes that being exposed to pure creative energy—especially in a warm and caring environment—has a profound effect on people. And that effect lasts long after the attendees have returned home. Says Teesha: "They will use the power of creativity more in their everyday lives and will pass it on if the opportunity arises. They will gain a greater sense of self-confidence in their abilities and their work. And they will remember the positive energy of the group and will do what they can to create groups in their own towns and cities and schools."

"My dream is that, upon leaving Artfest, people find themselves more responsive to their environments, holding a deeper connection to who they truly are and where they came from, and are left with an impression that is so strong that it makes them want to share their love of creativity with their communities."

artfest is ...

where artists go to develop a renewed sense of their artistic selves, recharge their batteries, and take part in a magical experience that no one can explain, but everyone feels. The mission of Artfest is to provide innovative educational opportunities and genuine, face-to-face interaction for the art community.

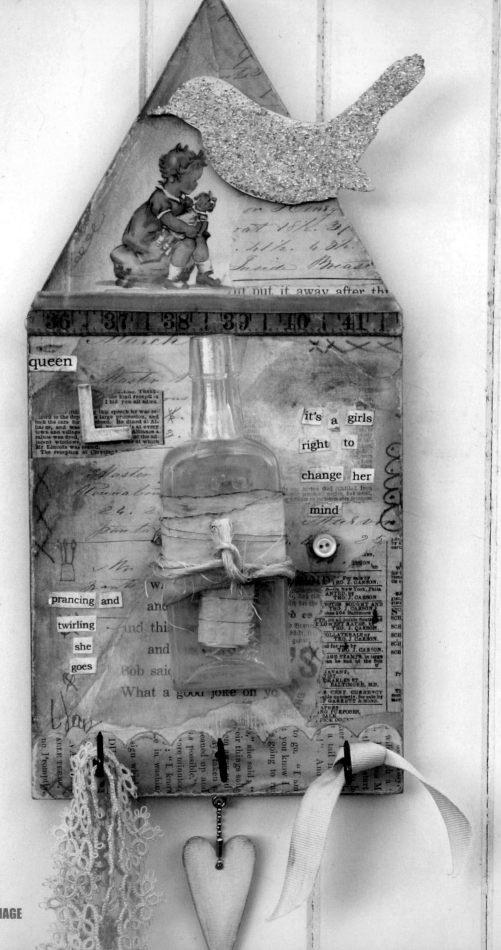

LISA KAUS

"Live life joyfully."
—Jonathan Lockwood Huie

A HANDS-ON APPROACH

Through all four years of high school, Lisa Kaus learned art from a single teacher—a talented artist and passionate educator named Nancy Kem. Nancy's way of teaching was to be incredibly involved with her students, but in a way that was very laid-back, as if she was "floating" around the classroom. Says Lisa: "She was never afraid to pull that brush out of my hand and illustrate a technique directly on my piece using a hands-on approach. She was such a big influence for me, and being able to have some of her work in my art was pretty cool."

REINVENTION

Stemming from her love of gardening, vintage treasures, and travel, Lisa's art showcases her classical art training with a unique twist that comes from listening to her intuition. Though she has been a self-confessed "paperholic" since childhood, the inspiration to incorporate collage into her paintings came from a good friend and fellow painter. "I was in a rut, and a friend told me that I should try putting some collage into my work," she says. "It was like the biggest lightbulb went on in my head. I made a total turnaround in my work; I reinvented myself."

Lisa doesn't expect her students to reinvent themselves in the course of one workshop, so she simply encourages them to explore new methods that they can apply to their own art-making process. She says: "Usually, there's one thing that really sticks with each student. It might be a creative way to use crayons or a technique for applying beeswax … just some element of the class that really intrigues them and makes them say, 'I'm going to keep working with that in my own art.'"

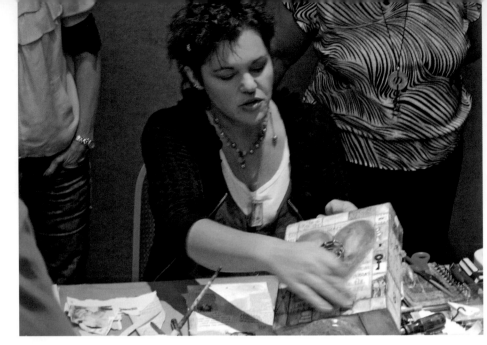

POINT OF VIEW

Lisa's keys to inspired and authentic living

- Being true to myself—by doing what comes naturally instead of what others want—is key. It can be especially hard when it comes to my licensing career, but it is absolutely worth the effort.

- I challenge myself to think differently in everything I do, whether it's art or trends or simply being willing to step off of the beaten path.

- I want to live by example, so I always try to conduct myself in a positive manner that is in line with my moral fiber.

ON THE MOVE

One of Lisa's secrets for an effective workshop is to keep moving around the classroom. She spends time with each student individually, providing encouragement and even jumping in from time to time with a hands-on demonstration, just like Nancy Kem did for her. "I ask for permission, and then I'll pick up their brush or pencil myself and do a demo directly on their project," says Lisa. "Everything about the workshop experience is very individualized, but I always see participants sharing and talking about their projects while they work, in essence learning from one another."

While Lisa loves it when her students are able to leave a workshop with a finished piece that they absolutely adore, that isn't her primary focus. She says: "Some people put so much emphasis on trying to create a perfect piece in the length of a workshop that they forget that the joy of a class is in the exploration of new techniques. I always make sure to remind my students to take each workshop for what it is, which is an opportunity to expand their artistic horizons."

she laughs

My husband, Dave, is my go-to guy and occasionally acts as my assistant during workshops. He's very likeable and funny, and always seems to do some typical "guy thing" that singles him out and makes the entire class laugh. Aside from being able to help with the hammering, drilling, and other tool use, he really livens up the classroom!

BORN TO TEACH

When Lisa held her first class in the basement of her old house, she was too busy focusing on all of the preparations to allow herself to get nervous about the teaching aspect of it. "I had to clean the house, cook the food, make sure everyone was comfortable ... I was more worried about all of those elements than about the class itself," she says. "Teaching felt so natural, like I was born to do it. It felt so unrehearsed and just seemed to pour out of me." Even now, Lisa finds the set-up of a workshop to be the most stressful part, so she always tries to get into the classroom early to lay out all of her materials and supplies in advance.

Says Lisa: "Everyone is capable of creating, no matter what background they come from or what their expertise is. It's just a matter of finding the technique or medium that really speaks to them, and then putting in the time to practice, practice, practice."

CREATING WITH LISA:
SECRET IN A BOTTLE

This is a fun project where your favorite paper ephemera can be coupled with a vintage bottle on a wooden substrate to create a very special piece with meaning and functionality. A few strokes with watercolor crayons, water-soluble colored pencils, and graphite pencil bring everything to life.

what you'll need

- 1-inch thick piece of wood, cut into the shape of a house (cuts can be made in most lumber departments)
- medium-grit sandpaper
- 1 sawtooth hanger and 2 small nails
- hammer
- Dremel drill
- white gesso
- large and small paintbrushes
- absorbent ground
- white glue
- wooden bird shape (or other wooden shape, found in craft stores)
- glitter
- extra-heavy matte gel medium
- assorted papers

- watercolor crayons by Lyra or Caran D'Ache
- water-soluble colored pencils
- rubber stamps
- bowl of water
- woodless graphite pencil
- assorted embellishments and objects
- strong-hold glue like E-6000
- vintage bottle
- 2 small nails
- craft wire
- needle-nose pliers
- 1 screw eye
- ball chain
- 1 wooden heart shape (or other wooden shape, found in craft stores)

techniques you'll learn

- collage
- color work with watercolor crayons and water-soluble colored pencils
- shade work with graphite pencil
- dimensional object assemblage and attachment

two

Apply a thin layer of white glue to the wooden bird shape and sprinkle a generous amount of glitter onto the glue to cover the entire surface and allow to thoroughly dry.

one

Sand the rough spots of the cut piece of wood and wipe it down with a damp cloth. Hammer a sawtooth wall hanger with two small nails to the back. Drill three pilot holes at the bottom front where three screw hooks will go. Drill one pilot hole at the bottom edge where you will later attach a screw eye. Apply a coat of white gesso to top and sides with a large paintbrush and allow to dry. Apply thick layer of absorbent ground with a paintbrush and allow to dry. This will allow for a nice and toothy surface.

three

Tear assorted papers and ephemera and collage them onto the house by using extra-heavy matte gel medium and a paintbrush.

four

Create strokes of color onto the surface of the house with watercolor crayons. Use at least three different colors. Blend colors with light strokes of water. Add layers of color with more strokes using different shades or a complementary colors. Use water-soluble colored pencils, and rubber stamps as desired. Mute any of the applications of color with applications of white gesso as desired.

five

Add doodles and marks with a woodless graphite pencil. Rub the graphite pencil on the edges of the house and then blend all pencil work with your fingers to blend and "dirty up" the piece.

create with Lisa at:

- Art & Soul (*www.artandsoulretreat.com*)
- Artistic Bliss (*www.artisticbliss.typepad.com*)
- Silver Bella (*www.paperbellastudio.com*)
- Her Personal Studio (*www.lisakaus.com/ showsandevents.htm*)

six

Attach found objects and other embellishments with a strong-hold glue like E-6000.

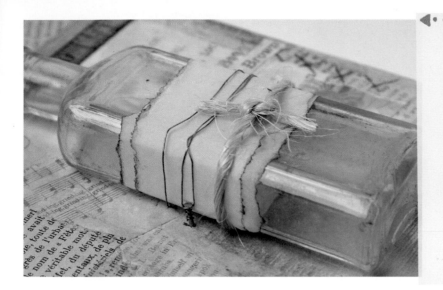

seven

Determine the placement of the bottle and then hammer two small nails into the house on each side of the bottle. Decorate the bottle as desired and wrap it several times with wire, leaving wire tails on either side of the bottle. Affix the bottle to the house with a small amount of white glue. Wrap the wire tails around the nails on either side of the bottle. Use needle-nose pliers to aid the final portions of the wire to get tightly wrapped around the nails.

eight

Attach three screw hooks into the pilot holes at the bottom of the house. Attach the glittered bird to the house with white glue. Attach screw eye into the pilot hole at the base of the house. Hang a wooden heart shape with a short ball chain onto the screw eye.

nine

Attach final embellishments as desired. Write a secret or wish onto a piece of paper and slip it into the bottle.

ideas & variations

- Consider using a regular rectangle or square shape as a variation to the house shape.

- Make one for the front or back entry to store important keys.

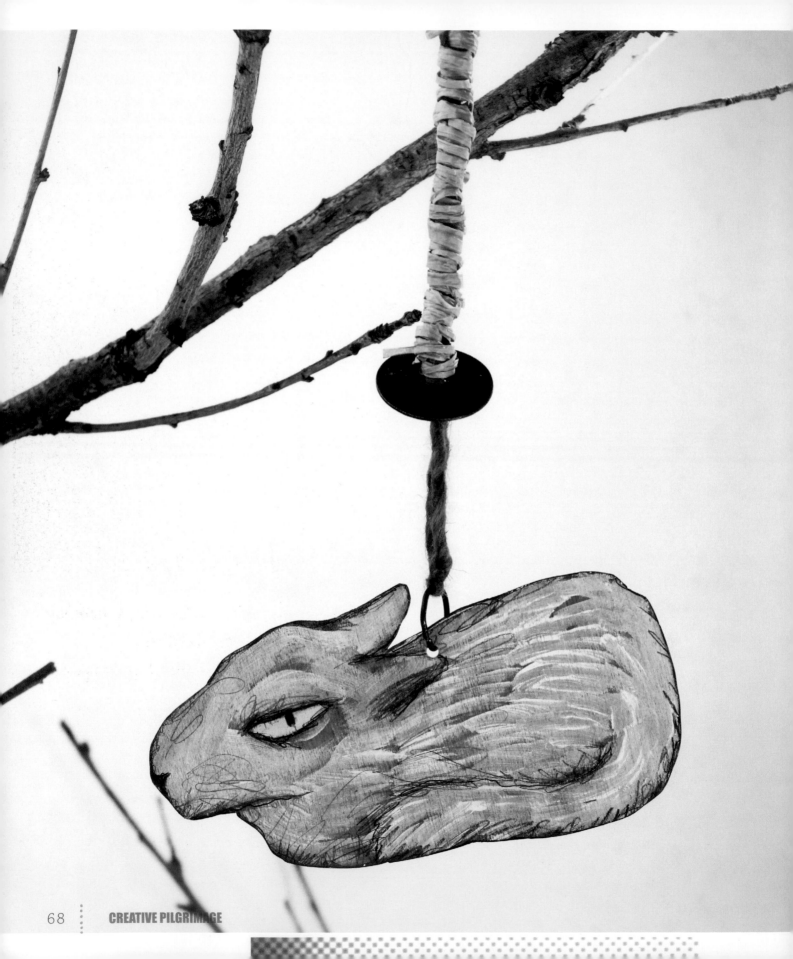

CREATIVE PILGRIMAGE

CARLA SONHEIM

A LOVE FOR TEACHING

If you ask Carla Sonheim about her favorite teacher, she'll tell you that there's only one name that comes to mind—Miss Rafferty. She spent both third and fourth grades in Miss Rafferty's classroom, a place that was warm, engaging, and filled with a genuine passion for education that was felt by all of her students. Says Carla: "She loved us. As her students, we could sense how much she loved being there, interacting with us and facilitating learning for each of our unique personalities."

GETTING SILLY

From her quirky animal sketches, like "Superdog!" and "Hippo Frog," to her sweet and fun paintings, like "Tire Swing Play," silliness is at the heart of everything that Carla creates. Years of experimentation have taught her to let go of fear and judgement and to simply do what feels natural, which is exactly what she teaches her students. Says Carla: "No matter what, the only thing we really have to offer is ourselves. If nothing more, I hope that students can come away from my classes feeling more 'themselves.'"

"If people never did silly things nothing intelligent would ever get done."

—Ludwig Wittgenstein

Each and every piece of art that is made during one of Carla's workshops contains at least one innovative element—the creative use of color, the attention to a specific detail—which is why sharing is a major part of all of her classes. "We do frequent walkabouts so that we can learn from and be inspired by other people's work," she says. "It's one of the benefits of attending a 'live' workshop."

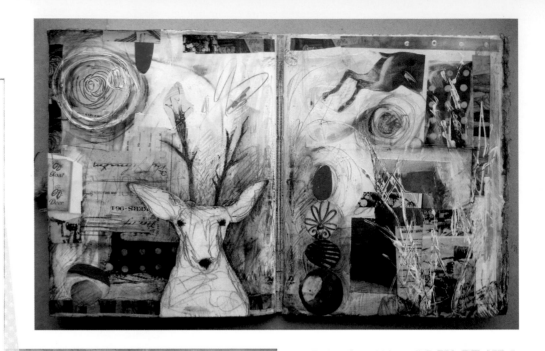

she laughs

I was doing a quick demo of a drawing exercise, and I scribbled some "orchids" onto my paper. Everyone else had already finished their pieces, so I was playing catch-up and had to hurry. The demo went on, and at one point I said, "My orchids don't look like orchids anymore." One of my students piped up, in the driest voice, and said, "they never really did." The whole class erupted in a ripple of laughter, including me.

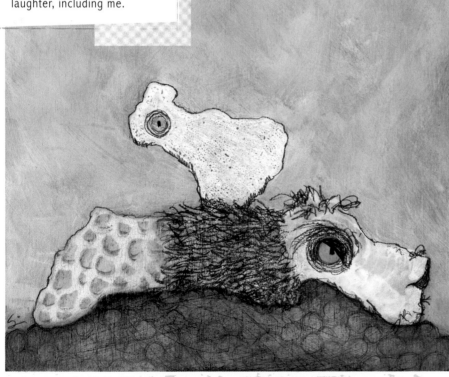

A FRESH PAIR OF EYES

In each of her workshops, Carla creates an atmosphere that is safe and supportive so that her students feel at ease, but still challenges them to move outside of their own comfort zones. She says: "I want them to feel relaxed, but I also know that deep down they want to be pushed just a tiny bit." It is Carla's view that being a "good teacher" means "giving students the permission to do what they already want to do," so she puts her energy toward helping them tap into and refine their own personal aesthetics instead of trying to change their styles.

Another of the ways that Carla supports her students is by being honest with them. If someone's art just isn't "working," she gently lets them know, and then offers suggestions on how to move forward. "Sometimes, all it takes is a fresh pair of eyes to ferret out problems or issues in a drawing or painting," she says. "Then I share a few ideas about what I might do to turn it around if it were my piece."

FOCUSING
ON THE POSITIVE

Despite having a serious case of "butterflies," the first class that Carla taught at Artfest went well, save for a few "stumbling moments." Though she expected that she would eventually get over the workshop jitters, she still finds herself feeling a bit nervous in the days and hours leading up to each class she teaches. However, with careful preparation and a positive outlook, she's always able to bring out the best in her students. "In the end, it's the attitude you bring to a space that will determine if it is a successful day or not," says Carla. "I always try to focus on the positive, and my students follow suit."

She has made a name for herself as one of the most sought-after instructors in today's art community, yet Carla is quick to turn praise she receives back toward her students. She says: "When you take a class from someone, you are basically just getting information about yourself—what you like and what you don't like. I'm pretty certain that if someone thinks that I'm a 'good' teacher, it's just because I help them bring out what is already inside of them."

POINT
OF VIEW
Carla's keys to inspired and authentic living

- I never learned how to "fake it," so I've always just done things my own way. I may have wanted to "fit in" when I was in my teens and twenties, but now I'm thankful that I do what comes naturally.

- Sometimes, I just have to stop everything and get out the paint. Excuse after excuse will keep me from painting, but if I squeeze some gouache out of the tubes, I'm committed.

- I try to go for walks as often as possible, because I find that a lot of ideas come to me when I'm outside and moving.

CREATING WITH CARLA:
DOUBLE-SIDED
CREATURE ORNAMENT

Using durable yet malleable, paper-thin wood as a
base, this project combines watercolor and sketching
techniques to create a one-of-a-kind creature ornament.
An effective layering technique involving paint, marker,
pencil, and gesso adds both highlights and shadows to
lend a dimensional look to the finished piece.

what you'll need

- blank paper
- ¹⁄₃₂-inch thick sheet of birch plywood (larger sheets can be cut down to create multiple ornaments)
- pink Crayola water-soluble marker
- gesso
- small paintbrush (for applying gesso)
- watercolors
- #12 round watercolor paintbrush
- light yellow Copic marker
- fine-grit sandpaper
- pencil
- spray fixative
- scissors and sharp craft knife
- hole punch
- hanging materials (yarn, beads, wire, etc.)

techniques you'll learn

- watercolor painting
- sketching
- adding depth using shading and highlights

Cut a random shape out of a piece of paper to use as a template.

two

Use a pink, water-soluble marker to trace your template onto the wood. Add eyes, ears, and other elements onto the creature with the marker. Note: Just create the basic shapes as more detailed features will be added in later steps.

three

Apply a "dry" layer of gesso using a small, relatively dry paintbrush. Use short, choppy strokes to create the feeling of fur, allowing some of the wood to show through. Let dry completely.

four

Add a layer of watercolor over the entire creature, leaving the eye area unpainted. Allow to dry thoroughly.

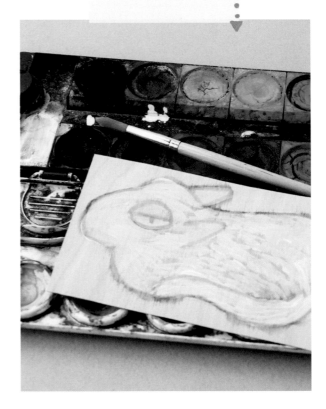

five

Use a Copic marker to apply a layer of yellow over the top of the ornament. The alcohol from the marker will remove some of the watercolor underneath to create white highlights, especially in areas where the gesso is thick. Note: Fine-grade sandpaper can be used to make the highlights stand out even more, if desired.

create with Carla at:

- Artfest (*www.teeshaslandofodd.com/artfest/info.html*)
- Journalfest (*www.teeshaslandofodd.com/1/journalfest.html*)
- LifeLabsNewYork (*www.lifelabsnewyork.com/silly.html*)

six

Add lines and shading to the eyes, ears, tail, and outer edges of your creature using a pencil.

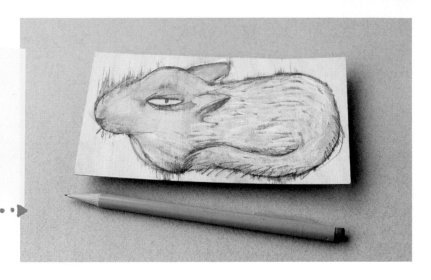

seven

Spray the entire piece with fixative, and let dry. Turn your ornament over and repeat steps two through seven on the opposite side to create a completely different creature. Use scissors or a sharp craft knife to cut out your painted creature. If necessary, use fine-grit sandpaper to remove any sharp edges.

eight

Punch a hole in your ornament and create a hanger using yarn, wire, and beads as desired.

ideas & variations

- When drawing your paper template, you can choose to develop a shape for a specific creature that you have envisioned or to sketch a shape at random.

- Make a series of ornaments and use them to create a unique mobile.

an artful journey

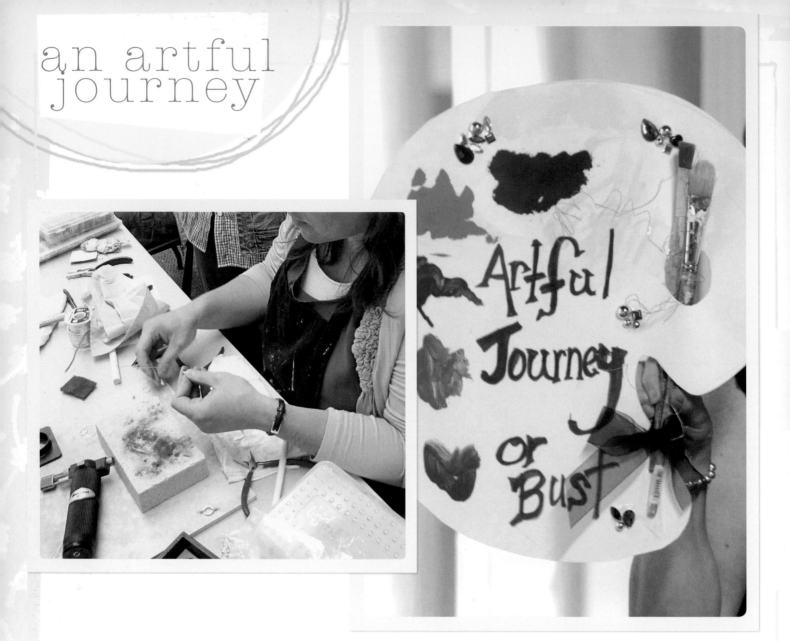

THE COMMON GROUND

Imagine spending three days immersed in the artistic process, developing a personal connection with a single instructor, at a scenic mountain retreat with other kindred spirits. That's the experience that An Artful Journey (AAJ) seeks to provide ... one where artists can get settled in, let their hair down, and "just be."

Only thirty minutes down the road from the San Jose International Airport, nestled among the redwoods in the Santa Cruz Mountains, sits the historic Presentation Center—an eco-friendly retreat and conference center that serves as the backdrop for AAJ. With "rustic and

quirky" accommodations and on-site classrooms, it's the ideal place for art lovers to get comfortable and creative. Each gathering welcomes no more than 90 students, thus creating a small and intimate learning environment.

AAJ Founder Cindy O'Leary understands that being an artist can be an isolated activity, so twice each year she brings together sought-after instructors with eager students to "discover the common ground" that exists between creative individuals. "No matter what our 'real lives' look like or where we come from, we're able to find powerful connections and see that we're not alone," says Cindy.

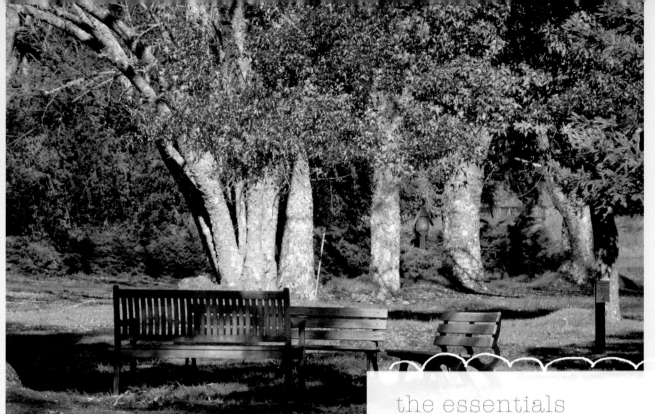

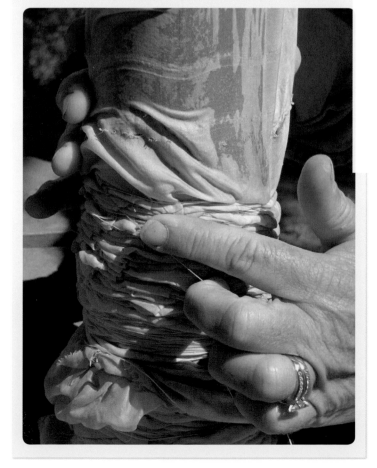

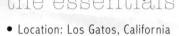

the essentials

- Location: Los Gatos, California

- Nearest Airport: San Jose International Airport in San Jose, CA

- Sessions: Annually in February

- Accommodations: The historic Pueblo Building offers single- and double-occupancy rooms, and communal cottages house 4–12 guests each.

- Website: *www.anartfuljourney.com*

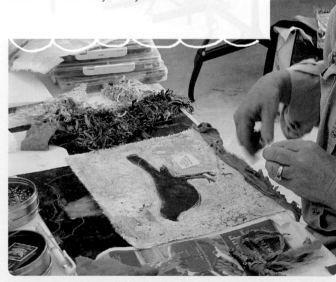

an artful journey

LIMITLESS POSSIBILITIES

Kelly Rae Roberts, Stephanie Lee, DJ Pettitt, Lesley Riley, Jesse Reno ... these names represent just a few of the inspiring teachers who have led workshops at AAJ. Attendees can choose to take classes in jewelry-making, painting and surface design, journaling, sewing, book-making, and other media during intensive sessions lasting up to three full days.

Among the imaginative workshops held at past AAJ retreats are titles like "Heart Strings," "Plaster Potential—An Exploration of a Thirsty Surface," and "No Limits." These creative classes allow artists to develop technical skills in conventional (and unconventional) media, and to build confidence in their own personal styles and abilities.

TRANSFORMATIONS

Stepping away from the hustle and bustle of daily life to take time for your artistic self can be transformative. Says Cindy: "It can be the catalyst for change and growth in your personal and artistic life, giving you the courage and strength to make positive changes; it can result in a new awareness about what you can offer the world; and it can lead you down a path to a more fulfilling life."

"My hope is that artists leave AAJ feeling that we're all part of a larger community ... that each of us has something to offer, and that the whole is always greater than the sum of its parts."

an artful journey is ...

a place to awaken your senses, nourish your soul, and replenish your spirit—to learn, share, and connect. The mission of AAJ is to encourage feelings of community, both for the attendees and the instructors.

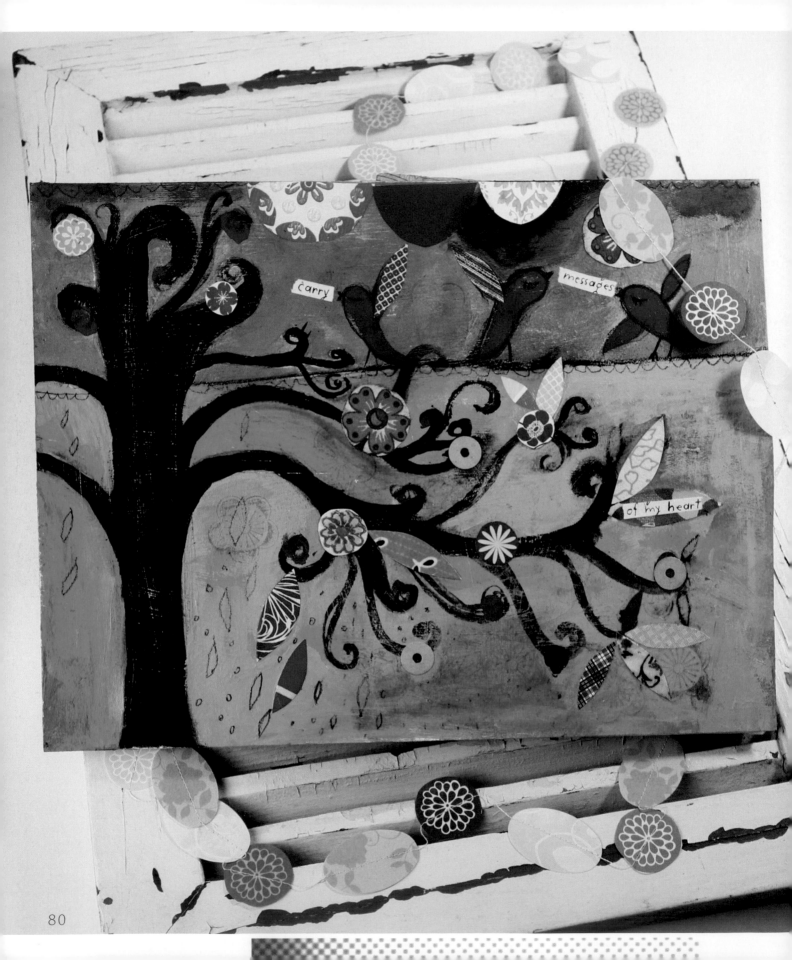

MATI ROSE MCDONOUGH

"The future belongs to those who believe in the beauty of their dreams."
—Eleanor Roosvelt

LEADING BY EXAMPLE

While attending her small high school in Maine, Mati Rose McDonough was introduced to metal-making and stained glass by her favorite teacher, Marcia Ryder. Though Mati's true passion was for painting, Marcia's way of teaching left an indelible mark on her. "She pushed us in a gentle way to be passionate about our beliefs and to do good work," she says. "She led by example, and always made sure that we had a calm space that was conducive to learning."

PAINTING LIKE A CHILD

Mati has spent her entire life—a journey that has lasted thirty-two years, taken her through two art schools, and lead her to paint approximately four hundred eighty-six pieces—learning to "paint like a child." Her art often features colorfully re-imagined animals paired with distinctive patterns, made using a mixture of acrylic painting and collaged elements. She draws inspiration from sources ranging from faded signs to Japanese pop art, and is always finding new and unexpected ways to blend styles and techniques.

It's no surprise that Mati approaches her workshops with the same youthful exuberance and playful attitude that comes through in her art. She says: "I take playing very seriously. Experimentation is a big part of all of my classes, and I try to make sure that all of my students have fun and feel comfortable diving into their paints."

SAFE & SECURE

Being a working artist herself, Mati knows just how intimidating a blank canvas can be—especially to those who are new to painting—so she strives to make every student feel at ease. "It's really important that I create a safe and supportive environment in my workshops so that students can share their work and ask questions without worrying about their own insecurities," she says.

While sharing the painting techniques and tricks that she's developed over a lifetime of artistic exploration, Mati has also found herself learning a great deal from the students she teaches. "Everyone has such incredible stories and backgrounds," she says. "I've learned so much from the wisdom of my students. The shared experience of baring our souls on canvas is very bonding, and is such a gift."

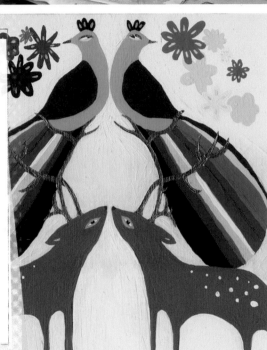

she laughs

Leading up to our retreat in Italy, Kelly Rae Roberts and I thought that one of our students was named "Tutti" because the organizer kept using the phrase, "Ciao Tutti," in his correspondence. When we arrived, we realized that "tutti" actually means "everyone." It was so silly!

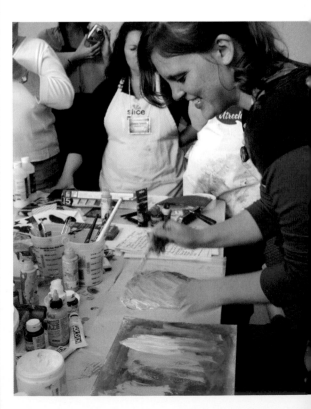

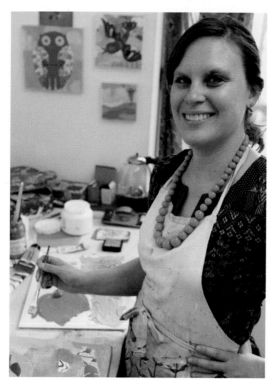

POINT OF VIEW

Mati's keys to inspired and authentic living

- Looking within for acceptance instead of comparing myself with others helps me to live authentically.

- I start every day with Julia Cameron's "Morning Pages"—an exercise in which I write three pages of longhand stream-of-consciousness as soon as I wake up—to help awaken my creative self.

- I keep my studio filled with inspiration binders and yummy art books that I regularly flip through as part of my creative ritual.

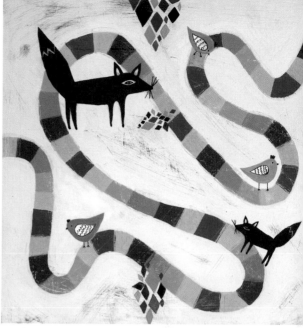

THE METAMORPHOSIS

The first class that Mati taught in a retreat setting was in Italy, alongside her friend and fellow teacher Kelly Rae Roberts. Between almost missing her flight, dealing with jetlag, and trying to overcome the "mega butterflies" she had in her stomach, Mati's teaching debut was not without its challenges. But as soon as class got underway, all of her stress just melted away. "From the beginning to the end, I was laughing, painting, and enjoying the creative process alongside my students and Kelly Rae," she says.

Mati considers herself lucky for being able to share her creative gifts with other artists. "Watching someone realize that they can make art that brings them joy, and then seeing them carry that excitement with them as they leave the class is simply amazing," she says. "It's such an honor to witness the growth that occurs over the course of a workshop."

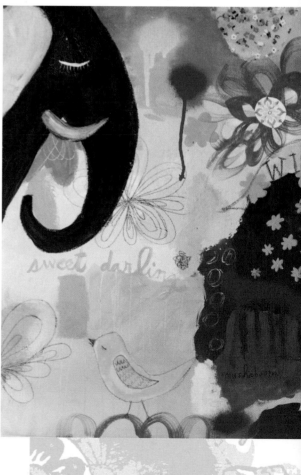

CREATING WITH MATI:
LAYERED FOREST PAINTING

This vibrant painting project uses a variety of techniques—ranging from finger painting to stenciling to paint spilling—and collage materials to build dynamic and expressive colored layers. Mati has distilled her painting method into five simple steps so that her playful style can be achieved by artists of all levels.

what you'll need

- 1 thick piece of paper (or other substrate such as cardstock or canvas)
- white gesso
- acrylic paints
- water
- paintbrushes
- assorted application tools (such as a brayer, credit card, spray bottle, and squeegie)
- pencil
- rubber stamps
- assorted papers
- scissors
- embellishments

techniques you'll learn

- non-traditional painting methods
- unique painting phases specific to Mati's process
- layering and shading with paints and collage

one

Prime the surface of your paper with a layer of white gesso. Allow to dry thoroughly.

two

Create color washes by diluting acrylic paints with water. Apply layers of color wash in your desired hues onto the paper. Mati refers to this step as "Just Picking Up the Brush," because the most important part is simply getting paint onto canvas.

three

Build texture into the piece by applying paint using a variety of techniques. Experiment with unconventional application methods, such as using a squeegee, spraying diluted paint from a spray bottle, spilling paint onto the canvas, using a brayer, or applying paint with your fingers. Allow each layer to dry before applying additional paint. In her workshops, Mati calls this step the "Curiosity Lab," because she encourages her students to try new techniques.

create with Mati at:

- An Artful Journey
 (*www.anartfuljourney.com*)
- The Art Nest
 (*www.theartnest.net*)
- Teahouse Studio
 (*www.teahouseartstudio.com*)
- Toscana Americana
 (*www.toscanaamericana.com*)

four

Sketch out the general composition of your piece with a pencil and fill in the sketch with paints. Mati names this step "Imagination Station," since it involves having students develop and refine the imagery of their paintings.

five

Using your sketch as a guide, continue adding layers of paint. Add rubber stamping and adhere pieces of assorted papers as you continue building the layers. Mati names this step "Conversation With Yer Painting," as it involves a process of embracing the chaotic and "ugly" phases that the piece may experience before it is complete.

six

After the painting has completely dried, add shading with a pencil, and additional collage embellishments. Allow yourself to be spontaneous and add any unique touches as you see fit. Mati refers to this stage as "Beauty in the Details."

ideas & variations

- If you find yourself stuck on any step, try working in three-second increments— focusing on one technique or one area of the painting for three seconds and then immediately moving to a different section of the piece or changing to an alternate method.

- Don't get discouraged if your painting takes a while to develop ... the more layers you add, the more complex and unique your piece will become.

artistic bliss

SPECIAL MOMENTS

Linen-covered tables, stunning centerpieces, delicious food, and lavish extras ... these are just some of the elements that make each Artistic Bliss (AB) retreat an "Affaire" to remember. Women from across the country join a roster of esteemed teachers at festively-themed AB Affaires, where they commune with other creative souls for a weekend of art-making, bonding, glitz, glam, and celebration. Between creating sparkling jewelry and ornate, mixed-media shadowboxes, attendees are treated to spectacular goodie bags, afternoon teas, and even costumed galas.

AB Founder Kim Caldwell believes that, as "constant givers," women should give themselves opportunities to feel special too, which she calls "nourishment for the soul." Says Kim: "Whether it's for an entire weekend retreat or a three-hour workshop, all artists deserve moments in which they can create— a time when they can learn in a beautiful setting with touches designed just for them—that they will remember and treasure forever."

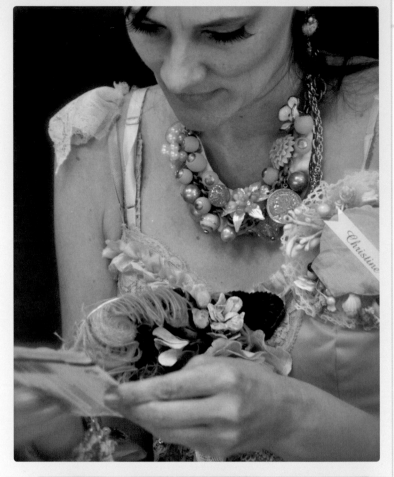

the essentials

- Location: Culver City, California
- Nearest Airport: Los Angeles International Airport in Los Angeles, CA
- Sessions: Weekend workshops and themed events held throughout the year
- Accommodations: Area hotels provide an array of lodging options.
- Website: *www.artisticblissdesigns.com*

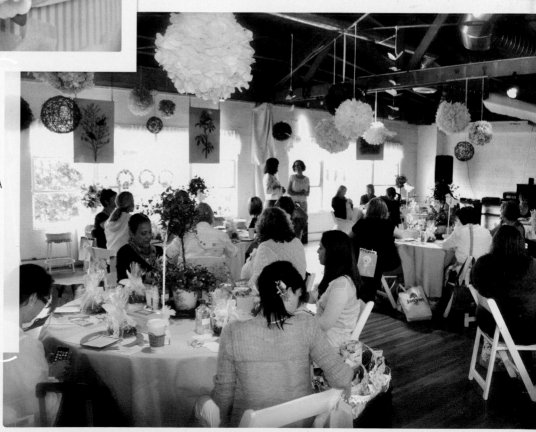

artistic bliss

DESSERTS & DECOUPAGE

Past AB events have been arranged around creative and elegant motifs like "L' Automne," which honored the festivities and traditions of autumn, and "Moulin Rouge," an extravagant weekend of French-inspired art and activities. Attendees have enjoyed themed classes in jewelry-making, mixed-media wall art, collage, and doll-making, in addition to other unique events, such as flea market excursions, dessert parties, and vendor markets.

These decadent class offerings are led by a diverse group of talented artists, including Julie Haymaker Thompson, Jenny Heid, Pam Garrison, Kerry Lynn Yeary, and many others. Together, they teach participants to stamp, stitch, paint, sketch, and glitter their way through workshops like "She Does All She Can-Can," "Romantic Fabric Wristlets," and "Sea Pixie Figurine."

artistic bliss is ...

a safe and nurturing environment that cultivates friendships by bringing together women who share appreciation of beauty and the arts. Through this, AB hopes to foster feelings of acceptance, community, and peace in those who attend.

STRENGTH & ACCEPTANCE

While Kim has seen the collective blossoming of ideas and inspiration that happens when creative people gather, she has also witnessed the deeper impact that the shared experience of an art retreat can have. "After hosting events for the last few years, I am certain that coming together as a group fosters appreciation of strengths among women and encourages them to not only be more accepting of others, but of themselves as well," says Kim.

"I am overjoyed at the end of each AB retreat, when I look into the eyes of the attendees and can see that they feel accepted ... that they risked, and succeeded. And that feeling is something that they will carry with them for the rest of their lives."

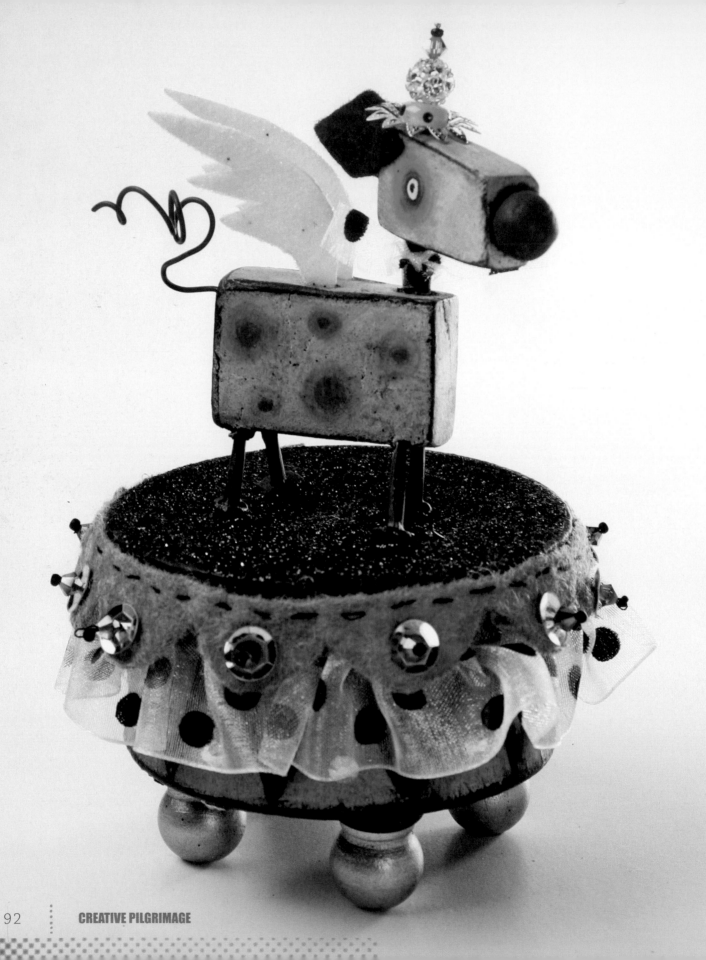

CREATIVE PILGRIMAGE

JULIE HAYMAKER THOMPSON

AN AWAKENING

Julie Haymaker Thompson's eyes were first opened to the possibility of a career in the arts by her beloved high school art teacher, Mrs. Poteet. When Mrs. Poteet took her class on a field trip to a local art school, Julie immediately knew that she had found her calling. "I didn't even know that schools like that existed until she took us there, and I realized right then and there that this school held my future," says Julie. "I am forever grateful to Mrs. Poteet for introducing me to this amazing, creative world."

JOY & WHIMSEY

If there's one word that describes Julie's art, it's "whimsical." From charming animal sculptures to folk art dolls, from playful paintings to rustic, miniature houses, her creative repertoire is vast and varied. But with a degree in illustration and classical training in both fine metal-smithing and ceramics, everything that Julie makes possesses a certain sophistication. "My work tends to be fun and not overly serious," she says. "Students come to my workshops with the hope that the teacher is as fun as her work."

"The only thing we have to fear is fear itself ..."

—Franklin D. Roosvelt

Living by the motto "the joy is in the journey," Julie uses her classes as an opportunity to encourage her students to look inward for acceptance instead of looking to others to measure their value. She says: "Looking inside ourselves for our self worth is one of life's hardest challenges. We all have the power to create our own journeys, so I try to infuse positive messages that will inspire my students to find joy in their own uniqueness into my classes."

POINT OF VIEW
Julie's keys to inspired and authentic living

- I've learned how important it is to follow my intuition. It's truly the voice of my higher power.

- We are all creative beings and each of us has our own special way of seeing, along with our own unique way of expressing our vision through our individual skills. Being true to my own artistic voice is a key to living my life authentically.

- Limitations breed creativity. I enjoy the challenge of working within my limitations—whether the limitations of time or self-imposed restrictions like making something with a set number of materials—because it forces me to continually hone and refine my own artistic methods.

CREATIVE EVOLUTION

Like her art, Julie's class structure is in a constant state of evolution ... always being refined and polished to better meet the needs of her students. Her current method of teaching puts the emphasis on technical demonstrations first, and then gives students the opportunity to spend the bulk of the class simply making art. Says Julie: "If I spend too much time lecturing and doing demos, students have little down time to create, and creative time is a very important part of the workshop experience." She's also careful to tailor the depth of the class to the amount of time available, so that her students don't leave feeling overloaded.

One of Julie's favorite parts of teaching is the "unexpected" lessons that have a way of coming up during workshops. She says: "In each class, students learn the techniques that I present, but they also gain knowledge that they didn't expect ... things that are perhaps unrelated to the primary topic but just come out in the teaching process. Sometimes it is the little, helpful tricks you walk away with that are the best part of a class, so I try not to hold anything back."

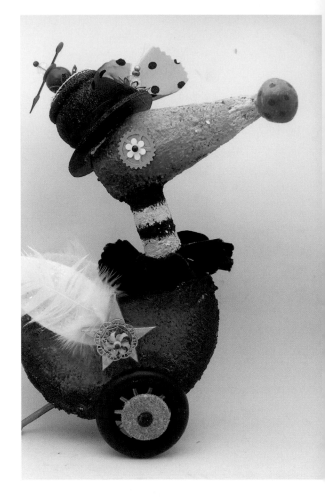

create with Julie at:

- Art & Soul (*www.artandsoulretreat.com*)
- Blisbee (*www.blissbee.net*)
- Frenzy Stamper (*www.frenzystamper.com*)
- Hacienda Mosaico (*www.haciendamosaico.com*)
- Paper Tales (*www.papertales.typepad.com*)
- Terri Brush Art Camp (*www.terribrushdesigns.com/Art-Camp.html*)

The first paper clay workshop I taught was my dog-making class. I thought I could teach it in only three hours, but I hadn't considered how long the clay takes to dry. We tried assembling them too early and they fell to pieces as we tried to paint them. We may not have finished our dogs, but we sure did share a lot of laughter.

FEELING RIGHT

Her career in the commercial art industry—as an art supervisor at Hallmark Cards—served as preparation for Julie's entry into teaching. Having spent many years working with and guiding artists professionally, Julie's first classroom experience "felt natural and right." She says: "I have always enjoyed sharing moments of creativity with other artists, so the workshop setting felt very comfortable for me. My career in the arts had taught me how to help people bring out their own talents and how to provide support as they develop their own artistic voices."

"As an artist, there are few greater feelings than having someone look at your work and say, 'I want to do that,'" says Julie. "To be able to share my time with other artists, to teach them a few of my favorite techniques, and to hopefully inspire them to follow their own muse ... that is a dream come true for me."

CREATING WITH JULIE:
MY OWN SPOT

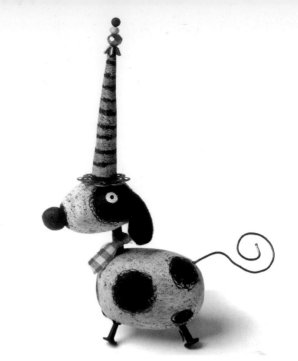

Basic shapes formed from paper clay come to life in this playful sculpture that's achievable by artists of all levels. A coat of chalkboard paint transforms the clay into a toothy surface suitable for decorating with colored pencils and acrylic paints.

what you'll need

- Paper clay, 4 ounces
- 4 tack nails, size 22
- 1 lollipop stick, cut to measure 1¼ inches (3.175 cm)
- 1 piece of 19-gauge annealed steel wire, 4 inches (10.16 cm)
- candle warmer (optional)
- craft knife
- fine-grit sandpaper
- slip: mixture of paper clay and water with putty-like consistency

- white glue
- black chalkboard spray paint
- Stabilo All (or Prisma) colored pencils
- black felt scraps
- scissors
- needle-nose pliers
- beads and metal bead caps
- ball-tipped pin
- ribbon, 4 inches (10.16 cm)
- pink pastel
- cotton swab

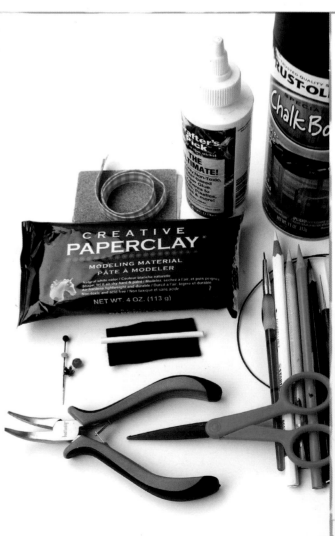

techniques you'll learn

- shaping paper clay
- assembling a small-scale sculpture
- shading with colored pencils

one

Roll paper clay into an oblong ball about the size of a hen's egg, using the palm of your hand for the dog's body. Roll another ball slightly smaller, with a softly tapered end for the head. Roll a third ball the size of a pea for the nose. If cracks occur while working with the clay, add a small amount of water to your hand and work it into the surface, smoothing as you go. If the clay gets overly wet and sticky, set it aside to dry for a few minutes.

two

Press four tack nails into the underside of the dog's body for the legs, turning them slightly outward for balance. Once they are in place, flip the body over and press the nails down gently against the tabletop to create an even balance.

three

Create a "pilot" hole for the neck by pressing the cut lollipop stick ½-inch (1.27 cm) into the top front of the body. Repeat this process on the bottom side of the dog's head.

four

Insert the cut wire ½-inch (1.27 cm) into the top back end of the dog's body for the tail. Set aside all of these parts to air dry. Speed up the drying process by placing the parts onto a candle warmer for up to three hours.

five

Roll out a tapered tube of Paper Clay to create the hat. Start with a ball about 1 inch in diameter, then place it on a flat surface and roll it with your hand into a cone shape. Cut excess with a craft knife and allow to dry. Remove any imperfections with sandpaper. Sand small flat spots onto the front of the dog's head, the nose, and the base of the hat.

six

Spread the slip into any cracks found on the pieces and smooth out the surface with your fingers. Allow to dry.

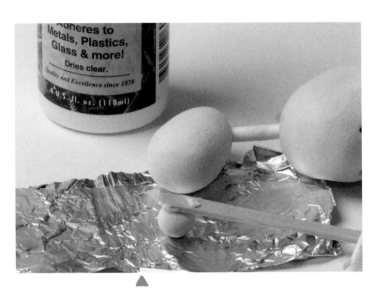

seven

Secure nail legs by dipping them into white glue and reinserting them into the pilot holes. Repeat this process for the neck piece, attaching the neck to both the body and the head. Attach the nose to the head with white glue. If the pilot holes have shrunk while drying, use a craft knife to scrape a small amount of dry clay from the holes. If the pilot holes are too large, add clay and glue to the holes before inserting the nails or the lollipop stick.

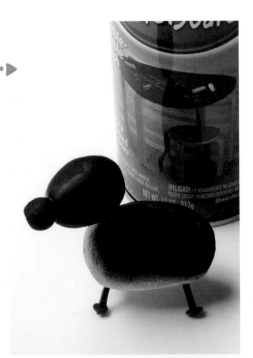

eight

Paint the entire piece, including the dog's hat, with black chalkboard spray paint and allow to thoroughly dry.

nine

Add white to the dog using a white Stabilo All (or Prisma) colored pencil. Use a black Stabilo pastel pencil and other accent colors to add details.

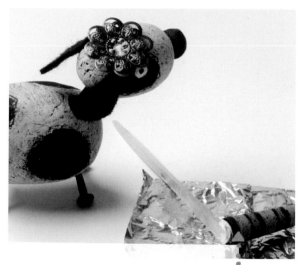

ten

Cut black felt into two teardrop-shaped pieces and use white glue to affix them onto the dog's head for ears. Curl the wire for the dog's tail with the help of needle-nose pliers. Dip the tip of the tail into white glue and insert it into the pilot hole.

eleven

Sand a small, flat surface on the top of the hat cone. Stack beads and bead cap onto a ball-tipped pin and press the pin into the top of the hat. Lightly sand the top of the dog's head and then glue the hat in place and let dry.

twelve

Tie ribbon around the dog's neck. Rub pink pastel onto a sheet of paper and then use a cotton swab to apply a small amount onto the dog's cheeks.

ideas & variations

- Create a pedestal for your dog by gluing four wooden dowel end caps onto a store-bought, papier-mâché box, painting it with chalkboard spray paint, and then decorating it with colored pencils and assorted embellishments.

- Experiment with variations in the scale and shape of the pieces used to build your dog to form other animals.

TRACIE LYN HUSKAMP

"Nature never did betray the heart that loved her."

—William Wordsworth

A UNIQUE VOICE

Tracie Lyn Huskamp began developing her signature style while in art school, under the guidance of a supportive teacher from whom she took a watercolor class. "She was a very nurturing individual, who constantly encouraged her students to work hard at finding their unique voice," says Tracie. "Her criticisms were always delivered in a positive and kind manner, as to not crush our creative spirit. Through her example, I learned more than just painting techniques … I learned the virtue of encouragement."

BACK TO NATURE

Tracie has a deep connection to nature and finds it to be a constant source of inspiration for her art. Her mixed-media works—a combination of painting, sketching, collage, and sewing—often include imagery of birds and plants, as well as found elements from her cherished garden. Not surprisingly, nature is also a frequent theme in her workshops, which are usually held in scenic locales. She says: "I am personally drawn to teach at events where the venue is closely intertwined with beautiful, natural surroundings. Then not only do I get to experience some really inspired moments inside the classroom, but also outside of the classroom."

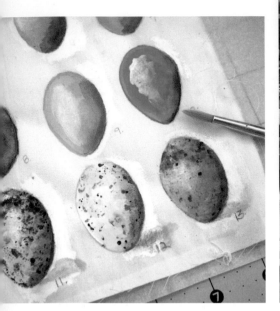

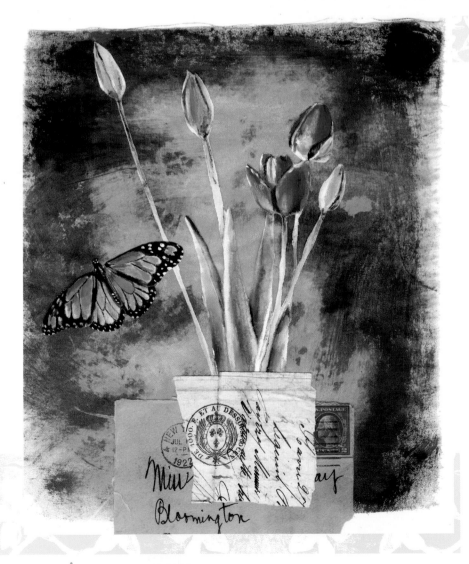

BEING ATTENTIVE

Even when she's teaching at large-scale retreats, Tracie makes sure to have one-on-one interactions with every student in her class. "It's important that I not only lead the class throughout the day, but also listen to each participant and address their needs," she says. "Hearing what they have to say helps me to keep the dynamics of the class moving in a positive direction." But Tracie doesn't just listen to their words ... she also pays attention to the body language and facial expressions of workshop participants so that she can provide guidance even when someone might be too shy to speak up.

Being attentive to her students has also led Tracie to make a few artistic discoveries of her own. Says Tracie: "I think no matter what class you participate in, you usually walk away with new and unexpected lessons. I have learned a number of alternate tips for working with particular products or for substitute products that can be used with specific techniques from artists who attended my classes."

A GUIDING LIGHT

Tracie's foray into teaching began with an invitation from Teesha Moore to host a workshop at Artfest. The weeks leading up her first class were filled with nervous energy, as she developed and refined her lesson plan, checked (and re-checked) the supplies she packed, and shipped her materials off to Port Townsend. "I had serious butterflies while setting up the classroom, but those nervous feelings melted away once everyone arrived," says Tracie. "It felt just like being with old friends."

Her role as a teacher is not one that she takes lightly, as each workshop she leads is the product of an extraordinary amount of thought and preparation. With her teaching assistant and mother-in-law, Marylin Huskamp, at her side, she strives to make every attendee feel nurtured, by providing helpful advice and by always being ready to jump in when needed. "I feel that it's very important for each of us to find our true selves and discover our gifts, and

it's my responsibility as an instructor to be a guiding light and an inspiration for those that choose to share time in my classroom."

POINT OF VIEW
Tracie's keys to inspired and authentic living

- One of my goals is to live my life with as few regrets as possible. I strive to find the courage to try new things, even when they seem difficult or out of reach, so that I'm never faced with wondering "what if?"

- Believing in yourself and trusting in your abilities is key. Before I could focus on learning and mastering my technical skills, I had to first have faith in myself.

- The most authentic gift I've given myself is the freedom to discover my unique talents, and then to find ways to share those talents in hopes of making the world a brighter place.

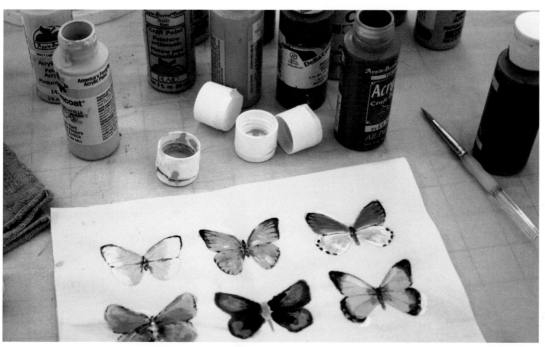

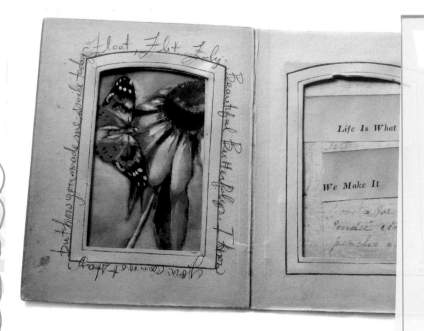

CREATING WITH TRACIE:
PETITE PAINT
& POETRY
PORTRAIT

This elegant, mixed-media project uses an easy but effective light box transfer technique to turn a photocopied image into a traced fabric sketch that is then accented with vibrant acrylic paints. Tracie uses a vintage photo album page to frame her finished piece, and adds a few of her favorite words to tie all of the elements together.

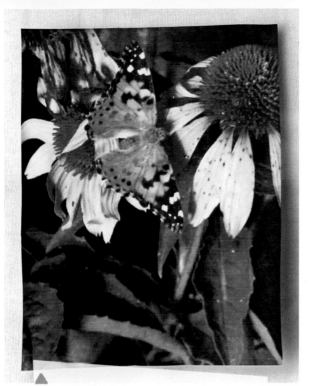

two

Correct any errors in color, lighting, contrast, and sharpness. Once the photo has been resized and enhanced, lighten the image by 30 percent to illuminate dark areas and make the details of the primary subject more distinguishable. The listed percentage is approximate, and may vary based on the contrast of the original photo. If you are not comfortable editing your image, or do not own editing software, trained staff members at your local copy center can help with your specific needs.

one

Select a photograph to use in your piece and scan it at the appropriate resolution [300 dots per inch (dpi) if enlarging the image, 150 dpi if keeping it the same size or reducing it]. Use photo editing software to crop the image, if necessary, and resize it to the desired length and height.

three

Print the image out onto a sheet of regular paper. If you can see clear outlines and major details in your photograph when you layer a piece of blank paper on top of the print and hold both sheets up to the light, then it has the right level of contrast.

four

Place the photocopied image onto your light box and secure it with artist tape. Position your muslin over the image, and apply artist tape on all sides to affix it to the surface. If you don't have access to a light box, then you can attach your photograph and muslin to a brightly lit window.

five

Trace the image onto the muslin using a mechanical pencil. When you've finished tracing the outline, use the pencil to add details to the drawing.

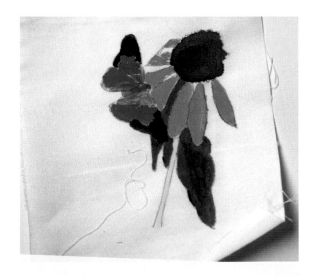

create with Tracie at:

- Adventures in Italy (*www.adventuresinitaly.net*)
- Artfest (*www.teeshaslandofodd.com/artfest/info.html*)
- French General (*www.frenchgeneral.com*)
- International Quilt Festival (*www.quilts.com*)
- The Festival of Quilts (*www.twistedthread.com*)

six

Load your palette with the desired colors of acrylic paint. Use paintbrushes to apply the paints to your sketch in layers. Allow to dry thoroughly. Tip: Break your image down into four to six large color areas, and begin laying down those large color blocks and leave the detail work for later.

seven

Center the completed artwork in one of the album page windows and secure by applying artist tape to the back of the page. Place additional artwork or decorative paper into an additional album page and tape in place.

eight

Apply matte medium along the back edges of the album, covering the artist tape. While the matte medium is still wet, affix additional decorative papers to cover the tape and artwork edges. Let dry completely.

nine

Embellish around the page windows with a written poem or quote.

ideas & variations

- This project can be enlarged or scaled down to be used with larger or smaller pages from a vintage photo album.

- Use artist tape to hinge multiple album pages together to create a free-standing frame.

valley ridge
art studio

A SHARED EXPERIENCE

There are few places in the world where those who are hungry to learn can take a workshop with their favorite artist, sit, and share a glass of wine with him or her, and even, at times, be a guest at a dinner that they prepared. The Valley Ridge Art Studio (VRAS) offers attendees an experience unlike any other, bringing talented "celebrity" artists to an intimate setting that's ripe for creative education and personal growth. In addition to offering technique-based art classes, VRAS hosts workshops that teach participants how to make creativity part of their daily lives through music, food, and even focused art therapy.

With a roster of sought-after instructors and a curriculum of original workshops, it's easy to see why artists flock to the rustic Wisconsin studio where VRAS is held. But, as proprietor Katherine Engen notes, a retreat is not just about taking classes, it's about "excitement, challenges, problem-solving, collaboration, pauses, laughter, and the myriad of emotions and experiences" that take place over the course of a workshop.

Coyote Crossing

the essentials

- Location: Muscoda, Wisconsin (70 miles west of Madison)

- Nearest Airport: Dane County Regional Airport in Madison, WI

- Sessions: Weekend classes during the spring, summer, and fall months

- Accommodations: Fully-furnished farmhouse and a small number of campsites. Typically one double bed for one guest per room.

- Website: *www.valleyridgeartstudio.com*

valley ridge
art studio

QUALITY TIME

VRAS gives attendees the unique chance to spend quality time with their favorite artists at in-depth, multi-day workshops in a variety of media. Jewelry aficionados can join Richard Salley to discover how to design their own tools for jewelry-making and metal-working, create their own one-of-a-kind cuff with Robert Dancik, or "DeSigN – dEsiGn – DesIgN" in a jam-packed workshop with Thomas Mann. Nearly twenty classes are held each year, giving art-lovers a diverse selection of innovative and informative options to choose from.

Other inventive classes offered at the VRAS have included topics such as mixed-media book-making, personal and creative development, painting, assemblage, and even cooking. With instructors like Michael DeMeng, Beryl Taylor, Mary Beth Shaw, and Michelle Ward leading workshops that encourage students to "Savor Life's Flavor," "Raise the Bar," and "Eat, Paint, Love," there are ample opportunities for building your artistic skills as well as your self-confidence at VRAS.

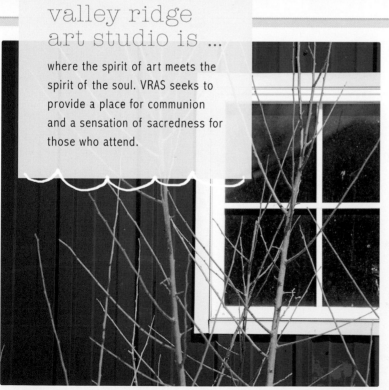

valley ridge art studio is ...

where the spirit of art meets the spirit of the soul. VRAS seeks to provide a place for communion and a sensation of sacredness for those who attend.

PRIDE & ACCOMPLISHMENT

Katherine has discovered that there's a certain magic that happens when creative individuals gather. "The energy of artists working together, side-by-side, is electric," she says. "Once everyone settles into a groove and begins to create, a vibrational energy reverberates as people innocuously become infected by each others' energy. Creative solutions emerge, new ideas blossom, and happy accidents occur."

"A sense of accomplishment in having learned a new technique, a sense of pride in having created a piece of artwork, a yearning to carry forward when they return home ... that's what I hope artists gain during a weekend at VRAS."

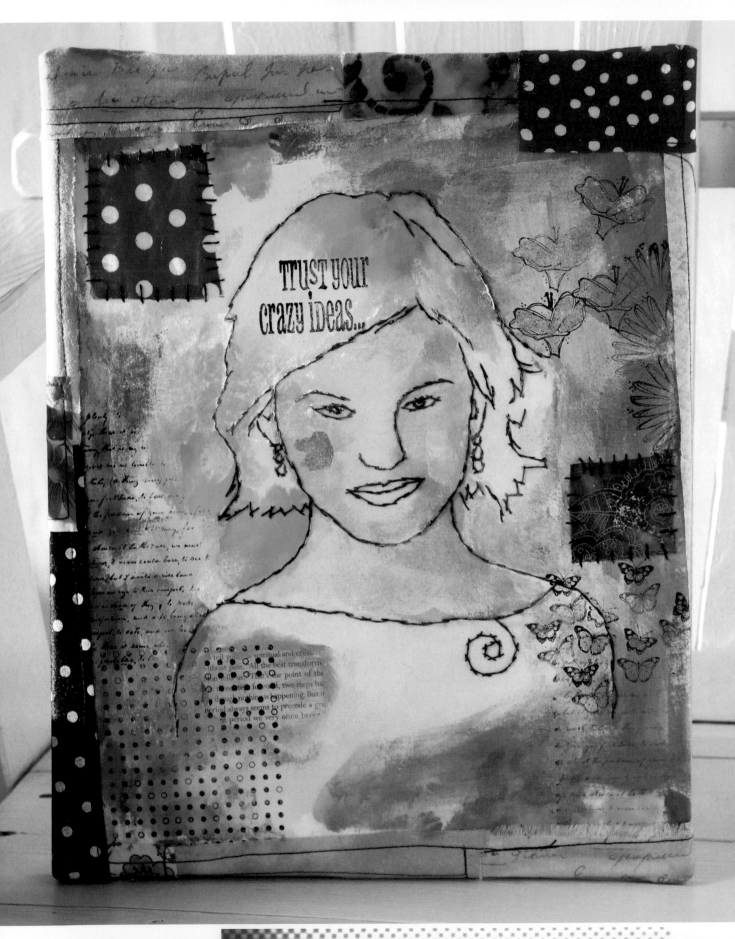

ALMA STOLLER

GETTING EXCITED

During a rare break from teaching, maintaining her arts-and-crafts blog, The Glossy Project, and making art, Alma Stoller enrolled herself in a "Beeswax Collage" class taught by Linda Womack. While she thoroughly enjoyed learning about using beeswax in art, what really inspired her was the way that Linda generated enthusiasm for her techniques during the class. Says Alma: "It was amazing. I loved her teaching style and all that I learned from her; she made me excited about the medium and truly made me want to continue exploring it."

POSSIBILITIES

The melodic, mixed-media compositions that Alma creates are reflective not only of her education in the visual arts, but also her classical training in music. She genuinely enjoys working in a varied range of media, including painting, sewing, collage, textile art, crochet, and embroidery. Because her passions are so diverse, she often blends notes cultivated from multiple art forms into a single project—adding embroidery to her collages, painting on textiles, and sewing on paper. "It's all part of the creative adventure," she says. "Anything is possible in art."

"Your work is to discover your work and then with all your heart give yourself to it."

—*Buddha*

Alma also aims to share her adventurous spirit with her students, as she provides both education and support through her unconventional, mixed-media workshops. Regardless of the specific project or technique that she's teaching, Alma's goal is to inspire her fellow artists to "create outside of the box" ... free of fear, self-judgement, and doubt. "I always try to push my students to make what is authentically them," she says.

POINT OF VIEW
Alma's keys to inspired and authentic living

- Create work that is authentic to you. Create art that echoes your voice and radiates your authenticity. That is where the joy of creating anything resides.

- I write, sketch ideas, and draw things just for myself in my journal. I think it's so important to have a journal where I can freely and fearlessly explore thoughts and designs.

- I stick with what feels right to me. This is true for both art-making and just living life.

MOVING FORWARD

More than providing critique or getting her students to master a skill set, Alma makes creating a welcoming and positive environment a top priority in every class she teaches. Says Alma: "I try to get my students to enjoy themselves, to surrender to their work, to be fearless in their approach. When we all start from the same mindset, we can all progress forward, gently and creatively."

Starting from a shared perspective also helps Alma keep the flow of her classes steady, and gives participants an opportunity to learn, laugh, and grow together. "I hope students leave my classes with a unique, finished piece of art, a greater understanding of the techniques that I use and the courage to explore them on their own, and a deep sense of community and friendship," says Alma. "And I hope they have a dandy good time, too."

CREATIVE ADVENTURE

Alma got her start in teaching through online workshops, which led to an opportunity to teach a class at Art Fiber Fest. The workshop—titled "Fabric Oddities"—was quirky and light-hearted, and proved to be the perfect setting for Alma's teaching debut. "The freeform nature of my class presented an exciting change for my students, and their positive reactions helped me to relax and allowed me to focus on sharing my ideas," says Alma.

In Alma's eyes, the measure of success for her workshops comes not from a finished project, but instead from being able to encourage her students and broaden their artistic horizons. "Art is about being fearless ... fearless with the materials, the instructions, the heart and soul you put into it," she says. "Knowing that my students walk away from my classes with a greater sense of creative adventure and freedom is unbelievably rewarding."

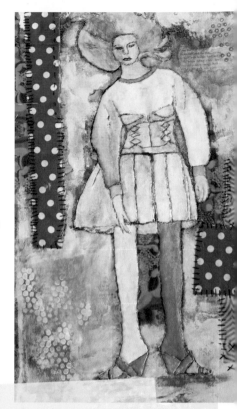

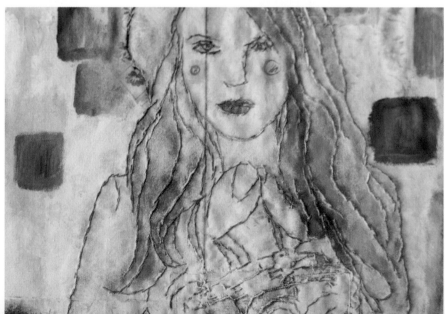

she laughs

Hand-sewing is very calming and relaxing, and whenever we get to that point in a workshop, the class immediately becomes a sewing circle. The students start sharing with one another, engaging in conversations about all sorts of things. Before long, we're all caught up in laughter over some off-the-wall discussion!

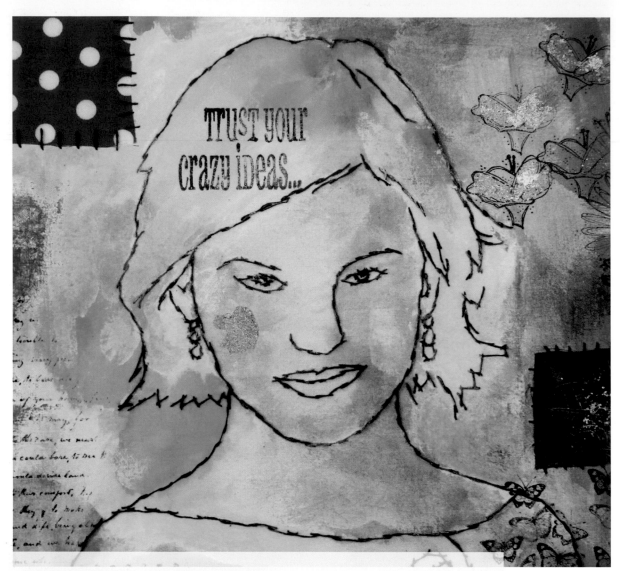

CREATING WITH ALMA:
EMBROIDERY +
MIXED-MEDIA=COLLAGE

A traced image transferred onto fabric acts as the
foundation for this embroidered collage, which uses a
stitch called the Glossy Backstitch to create a freeform,
impressionistic image. By exploring various surface
treatments, including painting, stamping, and doodling,
this project offers almost limitless possibilities.

what you'll need

- 1 piece of white fabric (or muslin), 10 x 13 inches (25.4 x 33.02 cm)
- magazine or photograph
- tracing paper
- pencil
- burnishing tool (such as a bone folder or back of a spoon)
- 1 piece of iron-on interfacing, 10 x 13 inches (25.4 x 33.02 cm)
- iron
- black embroidery floss and needle
- white or clear gesso
- watercolor and acrylic paints
- paintbrushes
- rubber stamps
- inkpads
- gold leaf
- scraps of patterned paper and fabric
- sewing machine
- pre-stretched canvas, 11 x 14 inches (27.94 x 35.56 cm)

techniques you'll learn

- embroidery
- collage
- surface decoration

one

Trace an image from a magazine or photograph with a pencil. Place the tracing onto the fabric, with the pencil marks facing the fabric. Rub the back of the paper with a burnishing tool to transfer the image to the fabric.

two

Iron the interfacing to the transferred image. This fused interfacing will make the fabric more sturdy and prevent the image from fading as you embroider it.

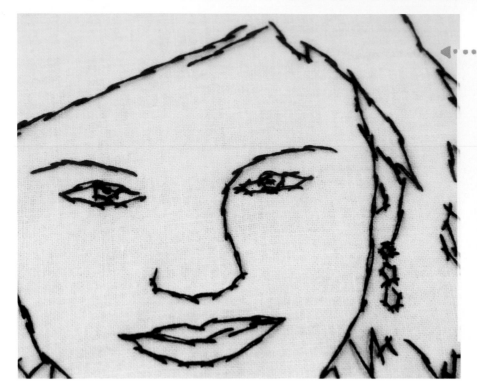

three

With the interfacing facing toward you, embroider the image with two strands of black embroidery floss using the Glossy Backstitch. The Glossy Backstitch is Alma's modification to the traditional backstitch, where the stitch length can be altered in a freeform manner. Once the entire piece has become embroidered, turn it over.

four

Apply a thin layer of gesso over the entire piece, including the embroidered stitches. Let dry thoroughly.

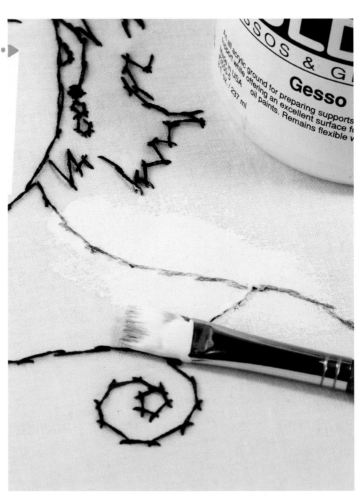

create with Alma at:

- Art & Soul (*www.artandsoulretreat.com*)
- The Art Nest (*www.theartnest.net*)
- Art Unraveled (*www.artunraveled.com*)

five

Add layers of color with paints and paintbrush. Hand- or machine-stitch pieces of paper and fabric onto the surface and add other details with rubber stamping and gold leafing.

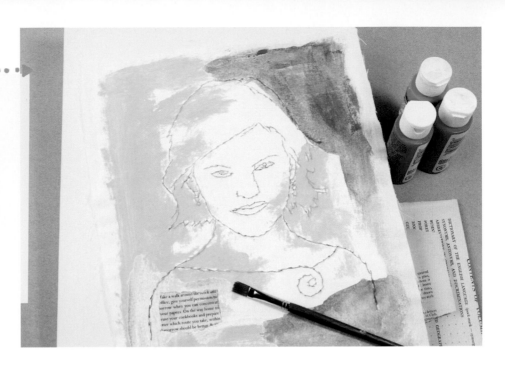

six

Hand- or machine-stitch scraps of fabric around the edges to create a border. Stretch and adhere the entire piece over a stretched canvas.

ideas & variations

- Add as much or as little decoration to the surface as you like.

- Embroider your image with bright and colorful floss for a different effect.

- Incorporate beads, pastels, markers, collage, or even traditional embroidery techniques into the background of your piece.

art & soul

CREATING CONFIDENCE

At various locations across the United States, artists commune at multi-day retreats to let go, to try new things, to make mistakes, to be vulnerable, and to be free. These retreats, known as Art & Soul (A&S), bring together art-lovers from around the globe to bond with one another and partake in workshops by internationally-recognized art instructors. With skill-building classes, A&S gives creative individuals at all skill levels the chance to interact and learn at their own pace.

A&S founder Glenny Demsem knows that the power of attending an art retreat lies in both the techniques that are learned, and in the way that artists see themselves after spending time with other like-minded souls. Says Glenny: "They gain confidence not only in their ability to be creative … they also develop a confidence and trust in themselves that goes beyond art."

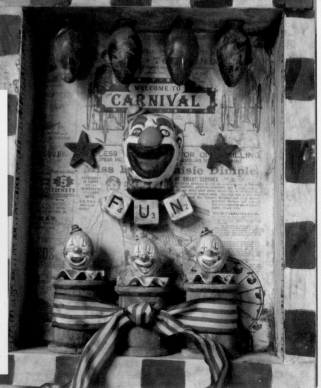

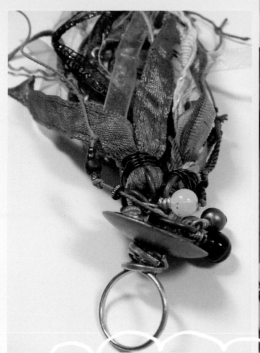

art & soul is ...

a creative retreat that brings artists together with exceptional instructors in a supportive and positive environment. The mission of A&S is to empower people to achieve their highest artistic goals through education and encouragement.

BASIC TO BOLD

New and veteran artists alike will find challenging and enjoyable workshops at each of the A&S retreats. The flagship event, held annually in Portland, Oregon, has featured dozens of sought-after teaching artists, including Jesse Reno, Lisa Kaus, LK Ludwig, Misty Mawn, and many more. This week-long event offers attendees an unmatched selection of topics—including painting, jewelry-making, stitching, metal-working, doll-making, textile design, and even letterpress—with unique class offerings like "Stories in Symbolism" and "Beeswax Bibliosemblage."

Artists who attend the retreats held in Las Vegas, Nevada and Virginia Beach, Virginia will find no shortage of innovative workshops to pique their interests. Those who are looking to explore a new media or want a refresher in basic skills can choose from skill-centered classes like "Learn to Saw" with Thomas Mann or "Soldering for Virgins" by Sally Jean Alexander. A&S also features bold workshops designed to help attendees push their creative boundaries, such as Ingrid Dijkers' "Instructional Guide for Going Over the Edge" and "Non-Traditional Forms in Wire" with Susan Lenart-Kazmer.

art & soul

A SPECIAL BREED

Artists are part of what Glenny calls "a special breed" ... a group of people who sometimes feel out of place in their day-to-day lives. "Being able to spend time around others who share the same habits makes them realize that they're not crazy, and that there are others like them," she says. "The understanding among these explorers is a confirmation of their creative soul that they will leave with and keep forever."

"A&S pushes some into a place of uncertainty and comparison, while others embrace the camaraderie and challenge. But regardless of how they come into the retreat, they leave a little bit stronger, a little bit more self-assured, and a lot more confident."

the essentials

- Location: Las Vegas, Nevada, Hampton, Virginia, and Portland, Oregon

- Nearest Airport: McCarran International Airport in Las Vegas, NV, Norfolk International Airport in Norfolk, VA, and Portland International Airport in Portland, OR

- Sessions: Three retreats ranging from four to seven days in length scheduled throughout the year, with occasional special events

- Accommodations: Area hotels provide ample accommodations with both shared- and single-occupancy rooms available

- Website: *www.artandsoulretreat.com*

GETTING IT

Every November, nearly two hundred artists flock to the Old Market—Omaha, Nebraska's flourishing arts district—for a weekend of learning, bonding, shopping, and art-making. This annual retreat, titled Silver Bella (SB), is a place where fans of shabby chic and vintage-inspired artwork can give themselves permission to indulge their creative sensibilities in the company of people who "get it."

The format of SB is simple ... attendees select five workshops taught by renowned instructors in a plethora of media, and all participate in a single group workshop as well as a vendor fair known as Bella Market. But, as past attendees (referred to as "Bellas") will tell you, a weekend spent at SB is anything but "simple." Between the classes, the art swaps, the dinners, the speakers, and the friendships that are made, one weekend at SB can have an impact that will last for many years to come.

As SB founder Teresa McFayden has seen, gathering together with people who share a common bond—such as the love for vintage-style art—can be "life affirming." "I've heard so many artists say that the people in their everyday lives just don't 'get it' or appreciate their fascination with shabby chic art, which leaves them feeling isolated," says Teresa. "So coming together and being in a huge room with others who do 'get it' is pretty empowering. It certainly builds confidence and fondness for what you love."

silver
bella

FROM BOTTLES TO BASKETS

Each year, attendees of SB can choose from close to twenty shabby chic workshops ranging from mixed-media and assemblage to jewelry-making and fabric art. Artists who are passionate about paper-crafting and mixed-media art will have the opportunity to take classes from talented instructors including Lisa Kaus, Lynn Whipple, Colette Copeland, Kerry Lynn Yeary, and many others. Past workshops have included unique offerings such as "The Gilded Cage," "Spirit Bundles," and "The Secret Inside the Bottle" to intrigue and enlighten both new and experienced Bellas alike.

Jewelry-makers and fiber enthusiasts also have plenty of vintage-inspired options to fill their weekend at SB. Top-notch teachers, such as Charlotte Lyons, Beth Quinn, Sally Jean Alexander, Betz White, and more, share their techniques in a variety of intimate workshops. With creative classes like "Josephine's Jewels," "Teacup Fairy," and "Nana's Basket" on the agenda, it's easy to see why dozens of jewelry and fabric artists make the trek to SB each year.

the essentials

- Location: Omaha, Nebraska

- Nearest Airport: Omaha Airport in Omaha, NE

- Sessions: One weekend retreat each November, with smaller events held occasionally

- Accommodations: The event is hosted at The Embassy Suites located in the historic Old Market in downtown Omaha, which offers single-occupancy and shared accommodations for attendees.

- Website: *www.paperbellastudio.com*

silver bella is ...

where artists go to create in the company of other artistic individuals who share a common interest in vintage or shabby chic art. The mission of Silver Bella is to make lasting memories by helping attendees develop their art-making skills and fostering new friendships.

LASTING EFFECTS

Each year, as SB ends and the attendees travel home, Teresa takes time to reflect on the experience they've shared and think about the lasting effects of the retreat experience on the whole. "If artists who attend a retreat were to look back twenty years later, they would likely see that they made friends who share their interests, that they stretched their talents by doing or learning something new, or that they met an artist they had long admired or a fellow blogger they looked up to. Above all, I believe that the experience would have made them feel more confident with their creative selves."

"It's enlightening and rewarding to think that people who come to SB might experience a transformation, that they see or feel a tingling in their soul as a result of being here, and find the courage to run with their ambitions."

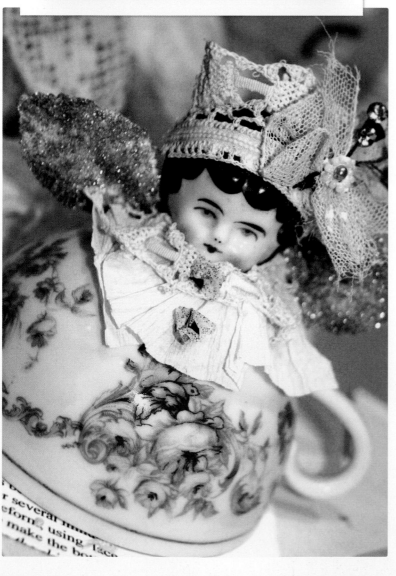

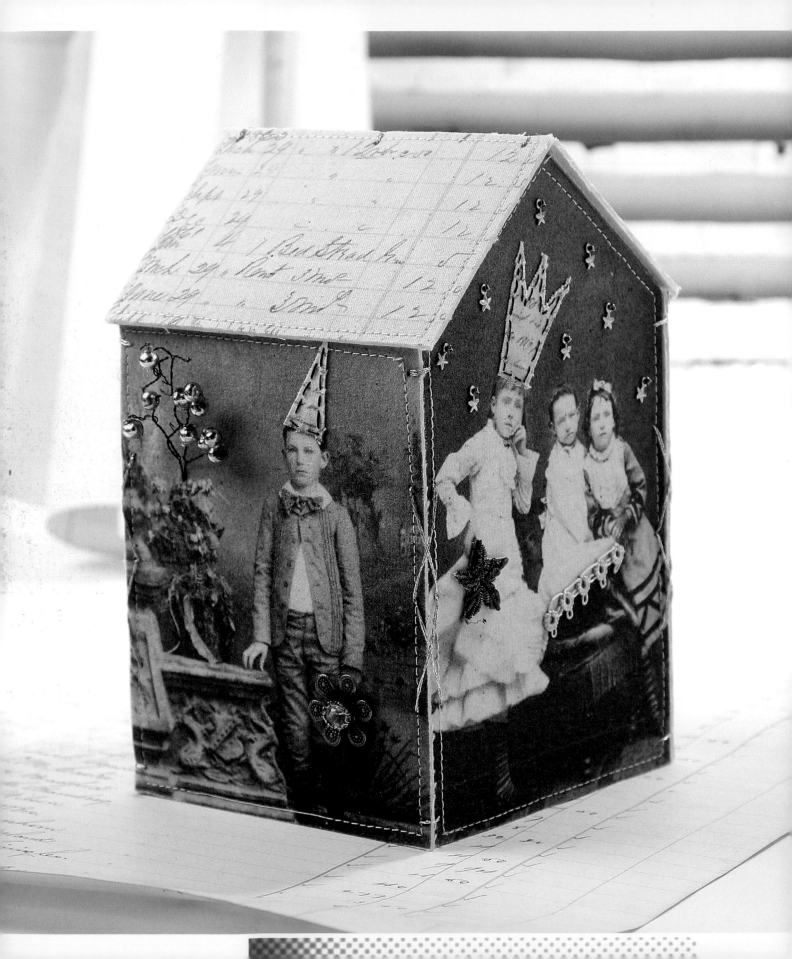

STEPHANIE JONES RUBIANO

FINDING DIRECTION

At a two-day workshop titled "Precious Little," Stephanie Jones Rubiano met teacher and artist Keith Lobue. His style of teaching so impacted her that he not only informed the way that she leads a class, but also changed the way that she makes art. "Keith is a natural teacher, and as a student you feel that he is giving you every little bit of information he has, without holding anything back," she says. "He's extremely approachable, and takes the time to work with each student so you feel that you are getting the direction you need to complete your project."

LAUGHTER & CREATIVITY

Stephanie is an avid collector of vintage photographs, as she finds the clothing, the settings, and the expressions in them to be a great source of inspiration for her art. Along with antique tins, text pages from old books, and authentic butterfly wings, these black-and-white images serve as the centerpieces of her captivating, shadow box-like artwork. But her style is far from "serious," with artwork titles including "You Compleat Me," "Darn It All," and "Ironical." Says Stephanie: "Laughter is a big part of my creative process, and I enjoy making it a part of my workshops too."

"How old would you be if you didn't know how old you were?."

—Satchel Paige

In Stephanie's eyes, the best part about teaching is seeing the way that a single idea is interpreted by a room full of creative minds. "I am always amazed at what my students come up with," she says. "The classroom is a place of sharing on so many levels, and I think we all take away more than we arrived with."

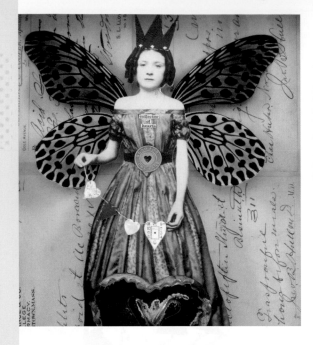

POINT OF VIEW

Stephanie's keys to inspired and authentic living

- I think that raising my daughter keeps me living an authentic life. Teaching her how to be strong and true to herself keeps me grounded and always striving to be the best person I can be.

- I view myself as someone who will forever be a student. I love learning new techniques, and I think that part of the creative process is to be always moving forward and trying different things.

- Exploring my local antique store is one of my favorite things to do. I can lose myself for several hours going through all of the wonderful offerings, and find that I am at my most relaxed during this time.

MOVING FORWARD

Keeping a group on task during a workshop can be difficult, since everyone works at a different pace, but Stephanie has learned that she can maintain the momentum of the class by breaking elaborate techniques down into smaller sections. "I do my best to keep everyone moving forward, giving instruction in several different segments so that the fast workers feel like they are getting the information they need to progress, but the slower-paced students have a bit of time to get settled with each new piece of information before we move on," she says. This approach also allows her to be "part of the classroom flow," moving through the space and checking on each individual student as she goes.

Artists may come to Stephanie's workshops for a variety of reasons—to learn a specific technique, to meet her in person, or to discover her creative process—but her goals for each class are always the same. She says: "I want my students to walk out of my classes knowing that they are all artists and that they should listen to that inner voice that drives them to explore and create the beautiful things that they conceive in their minds and hearts."

A HUGE STEP

Being an introvert by nature, Stephanie's first foray into teaching was "a huge step" for her. Although she had taken classes in public speaking, leading a group of people through a project was a different experience—one that she didn't feel entirely prepared for initially. She says: "Once the class started and the students were working, I was astonished at the change in my feelings as I began to relax and enjoy watching what everyone was creating under my direction. At the end of the class, I found that I was just as thrilled with their finished projects as they were."

"I would like to think that once a student has spent the day or evening with me in a workshop that they have acquired more than just a technical art lesson," says Stephanie. "I hope that I gave them the encouragement to try something new or helped to refine a technique that they might have struggled with in the past. I hope that they hear their hearts saying, 'yes, I am an artist ... look what I made!'"

she laughs

When I first started teaching, I was doing a lot of classes that involved shrink plastic. During one particular workshop, I noticed that one tray of plastic just wouldn't shrink. I pulled the tray out and picked up one of the pieces, only to **realize** that it was actually a piece of shiny, white cardstock. Evidently I had mixed a piece of cardstock into my stack of plastic ... I was really embarrassed, but the class thought it was hilarious!

CREATING WITH STEPHANIE:

THREE-
DIMENSIONAL
PHOTO HOUSE

A standard inkjet printer is used to transfer vintage photographs onto blank sheets of muslin, which are then embellished with beads, trims, and embroidery. Stiff interfacing acts as a stabilizer for the panels, allowing them to be stitched together into a beautiful, free-standing structure.

what you'll need

- heavyweight ecru muslin, ¼ yard (.23 m)
- iron
- copy paper
- repositionable spray adhesive
- scissors
- assorted vintage photos and paper ephemera
- photo-editing program and computer
- inkjet printer
- double-sided stiff fusible interfacing, ¼ yard (.23 m)
- matte finish acrylic spray
- sewing machine and basic sewing supplies
- ruler
- black permanent marker
- assorted embellishments like beads and sequins
- metallic embroidery floss
- Nymo beading thread, size D
- beading needle, size 10
- embroidery needle, size 24
- awl

techniques you'll learn

- sewing
- three-dimensional fabric sculpture
- printing photographs onto fabric

create with Stephanie at:

- Art & Soul
 (*www.artandsoulretreat.com*)
- Artfest (*www.teeshaslandofodd.com/ artfest/info.html*)
- Houston Center for Contemporary Craft (*www.crafthouston.org*)

one

Iron the muslin to remove wrinkles. Spray a piece of copy paper with repositionable adhesive. Lay the paper on the muslin and smooth from the center out toward the edges. Cut the muslin to the size of the adhered paper and trim off any excess threads along the edges.

two

Select four vintage photos and size them on your computer so that two of them measure 3½ x 4½ inches (8.89 x 11.43 cm) and the other two measure 3½ x 6 inches (8.89 x 15.24 cm). These images will become the house walls. Feed the muslin paper sheets into an inkjet printer that is set for regular paper and high-speed printing and print the four sized images. Size and print ledger paper or other ephemera onto paper-backed muslin to create two roof panels that each measure 3¾ x 2½ inches (9.52 x 6.35 cm). Allow all printed muslin sheets to dry for 30 minutes.

three

Cut the printed images with an added ¼-inch (.635 cm) border around all the edges. The paper backing should still be on at this point. Use these cut panels as templates to cut matching muslin pieces and double-sided stiff fusible interfacing pieces. Trim the interfacing pieces on left and bottom sides so that they are slightly smaller than the muslin pieces.

Create a panel "sandwich" by laying down the back muslin piece, the interfacing, and the printed muslin piece (with paper backing removed). Fuse the sandwich together with an iron, following manufacturer's instructions. Do not use the steam function on the iron, as this will ruin the printed inkjet image. Repeat for all panels.

four

Allow panels to cool completely and spray them with a light coating of matte finish acrylic spray and allow them to dry completely. Trim around the edges to remove the extra ¼ inch (.63 cm) of muslin on all sides of the panels. For the taller panels, measure and mark the mid-point of the top width with a black permanent marker. Measure and mark both sides at 1¾ inches (4.44 cm) from the top. Use these marks and a ruler to draw two intersecting lines and cut at these lines to create two house-shaped panels.

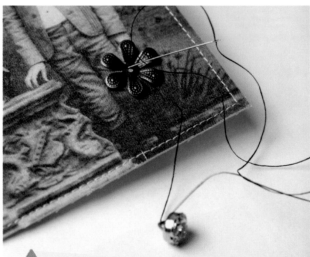

five

Stitch around all edges of all panels, ⅛ inch (.317 cm) away from the edge. Embellish the panels by adding beads, trims, and decorative stitches with beading thread and beading needle. If you have a difficult time getting the needle to go through the panels, use an awl to help open up the holes.

six

Make five marks along both sides of each wall panel, evenly spaced, at the stitch line. Use an awl to create holes at these marks to allow a size 24 embroidery needle to pass through. Thread two #24 embroidery needles at either end of two strands of metallic embroidery floss and sew up the sides of the house in a decorative manner.

seven

Make three marks along one side of each roof panel. Sew the panels together in similar fashion.

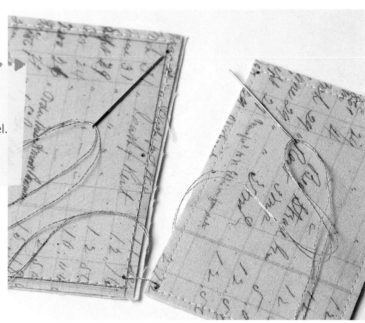

eight

Allow the four-panel house to fold and stand and then place the roof on top to complete. This stitched house can remain upright as shown or folded and collapsed.

ideas & variations

- You can use the crop function of your preferred photo-editing software to make the photographs the exact size of your panels
- The size of the house can be scaled up or down by varying the dimensions of your panels.
- Try adding free-form stitching or bead embroidery to the background of your panels or to accent the clothing in the photographs for added effect.

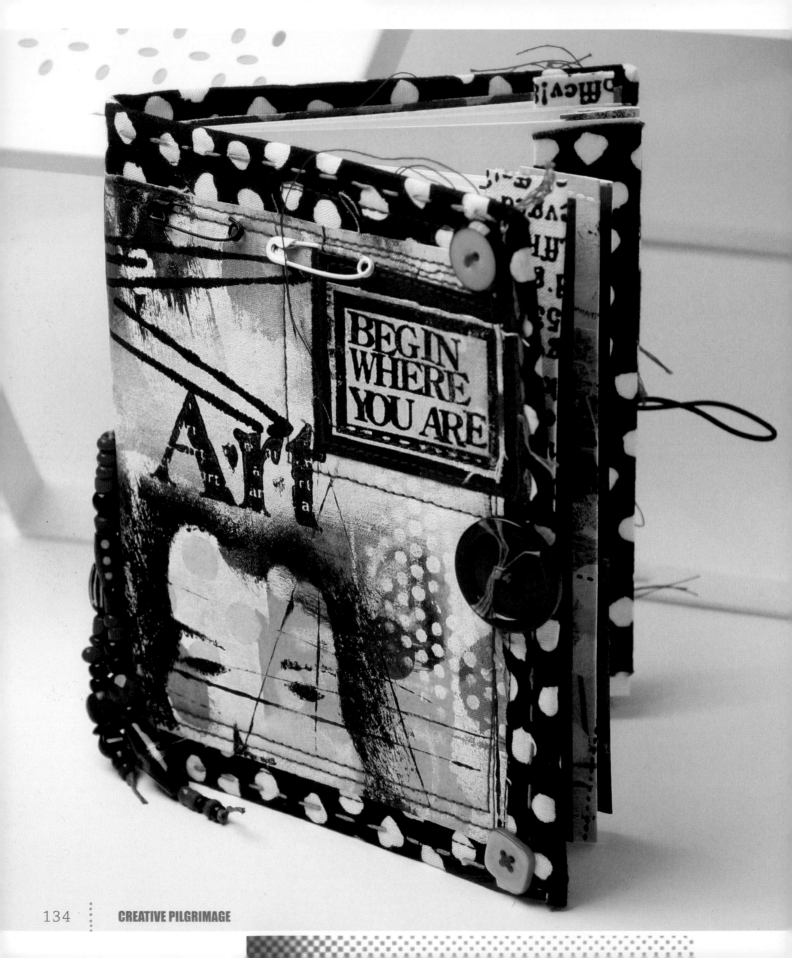

ROXANNE PADGETT

THE FREEDOM TO BE

Roxanne Padgett can recall many teachers throughout her life who taught her lessons that she still carries with her today. There was Ms. Rodriquez, who let her fourth grade class sing contemporary songs while they did their math work … and even provided accompaniment on her guitar. And also Ms. Allen, who encouraged her students to write from their own experience and always treated them as serious writers. Even more than the knowledge they shared, it was the way they treated their students that stuck with Roxanne. She says: "It was their ability to let students be who they were through learning and the creative process that really impacted me."

NO FEAR

Roxanne's personal artistic mantra is "fear no color," which is immediately evident when you look at her dynamic, mixed-media compositions. Her use of bold, vibrant colors—often in unexpected pairings—is one of the unifying elements of her body of work, which ranges from journals to paintings to sketches to collages. She is equally fearless about layering materials in her artwork. Fabric on paper, paint on fabric, stitching on paper … Roxanne is constantly exploring new ways to blend her favorite materials in her art.

"Courage is knowing what not to fear."

—Plato

She also infuses her classes with the same adventurous attitude, encouraging her students to set aside their notions of perfection and focus instead on simply tapping in to their creative selves. "The creative element resides in every human being; it's just a matter of learning to access it," says Roxanne.

POINT OF VIEW
Roxanne's keys to inspired and authentic living

- For me, surrounding myself with supportive people is a key part of living authentically. It's easier to pursue my passions when I receive encouragement from my inner circle.

- When I set a goal for myself, I immediately begin figuring out what steps I'll need to take to get there. Energy follows thought, but I have to take action if I want to make something happen in my life.

- I keep several journals going at once—I always have one or two in my purse, a couple at work, and a few at home. Any time I have a few spare minutes, I jot down a list or doodle in whichever one is handy.

STRUCTURE & THE UNEXPECTED

In Roxanne's eyes, a great classroom experience depends on the balance of two things—structure and the unexpected. She diligently prepares for each workshop by repeating her projects at home and taking step-by-step notes to create an outline for her lesson. "It's important that the techniques that I advertise are exactly what the participants get from a class," she says. But Roxanne has learned that leaving room in her class schedules for "the creative unknown" is just as vital as the technical instruction she provides. She says: "Each student must be able to find elements of themselves within their work, so I make sure to leave time for play and exploration within every class."

Her work with the Museum of Children's Art has also been influential in guiding Roxanne's teaching style. "Children are fearless with their art, and they'll try anything," she says. "Adults can sometimes be timid about branching out into new areas, and as a teacher, I try to help them remember that same fearlessness from their childhood."

THE CREATIVE EXERCISE

Roxanne realized early on that she wanted to be both an artist and a teacher, and spent much of her childhood playing school with her sisters, friends, and stuffed animals. "I could entertain myself all day, 'teaching' and making art," she says. Her audience may have grown a bit since then, but Roxanne still has the same excitement about teaching that she did as a child. "I have a little knot in my stomach just before every class," she says. "But as soon as the class begins, the knot instantly goes away and I relax into the moment and enjoy the creative process of teaching and learning from one another."

Says Roxanne: "I don't think of the end of a class as the end of the learning process, but as just the beginning spark. Being creative is like exercising a muscle ... the more you use it, the more you have."

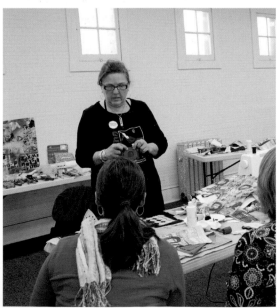

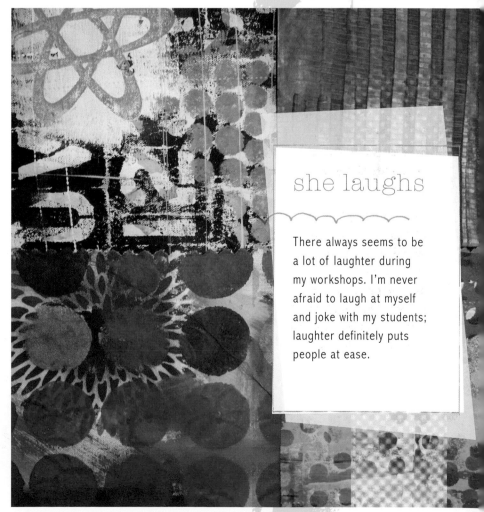

she laughs

There always seems to be a lot of laughter during my workshops. I'm never afraid to laugh at myself and joke with my students; laughter definitely puts people at ease.

CREATING WITH ROXANNE:
MIXED-MEDIA FABRIC JOURNAL

Paint, paper, fabric, and stitching come together to transform a piece of blank canvas into a one-of-a-kind art journal cover. Using a sewing machine and basic book-making techniques, the cover is transformed yet again into a functional and inspiring mixed-media journal.

what you'll need

- 2 pieces of canvas, each 9¼ x 5½ inches (23.49 x 13.97 cm)
- pencil
- acrylic paints and paintbrush
- fabric and paper scraps
- glue stick
- matte medium (optional)
- crayons (or other mark-making materials)
- 1 piece of heavyweight interfacing, 10 x 6 inches (25.4 x 15.24 cm)
- sewing machine and thread
- 2-inch (5.08 cm) wide fabric binding, 34 inches (86.36 cm)
- thick sheets of paper for signature, each 9 x 5½ inches (22.86 x 13.97 cm)
- waxed polyester (or other sturdy string)
- handsewing needle
- embellishments

techniques you'll learn

- sewing
- mixed-media collage
- book-making

one

Lightly sketch a design onto the piece of canvas using a pencil.

two

Paint in the drawn sections with acrylic paints, allowing the paint to dry thoroughly.

four

Use crayons and other drawing materials to add accents to the top layers of your piece. Incorporate stitched accents as desired. Repeat this process to embellish and decorate the second canvas piece.

three

Add fabric and paper scraps to the canvas, using a glue stick or matte medium to adhere them. Continue alternating between paint and collaged paper and fabrics until you achieve the desired effect. Let dry completely.

five

Bind the heavyweight interfacing with fabric binding. There are many quality tutorials on the Internet that teach mitered binding methods. I recommend searching "how to bind a quilt" using Google to find a video tutorial to aid you in this process. An alternative to mitered binding is to cut two strips of fabric that measure the widths of the interfacing and two strips that measure the lengths. Fold one strip over one edge and stitch in place. Repeat with all edges. Stitch one of the prepared canvases to one side of this bound interfacing. Stitch the second prepared canvas to the opposite side of the interfacing.

create with Roxanne at:

- Artfest (*www.teeshaslandofodd.com/artfest/info.html*)
- A Work of Heart (*www.aworkofheart.com/*)
- Journalfest (*www.teeshaslandofodd.com/1/journalfest.html*)
- Museum of Children's Art (*www.mocha.org/*)

six

Fold the thick sheets of paper in half, width wise to form a signature for the journal. Paint, doodle, and decorate some of the pages as desired.

eight

Decorate the inner pages as well as the cover as desired, using brads, trims, paper ephemera, and photographs, ribbon, found items, charms, and other embellishments.

seven

Fold the cover in half and stitch the signature into the center using waxed polyester and handsewing needle, with a pamphlet stitch.

ideas & variations

- Working on several canvases at once gives the layers time to dry between each process

- If a specific piece that you are working piques your interest at a given moment, try focusing your attention on that one page and move on to the others when inspiration strikes

- Select a theme for your journal, such as portraits or a specific color palette, and see how far you can push that one idea

CREATIVE PILGRIMAGE

HEATHER SMITH JONES

MAKING CONNECTIONS

Heather Smith Jones has had many gifted and influential teachers throughout her life—people who have pushed her to excel by lending both their knowledge and their support. Although their areas of expertise may have varied, their approaches to teaching share common threads. "There have been a number of teachers whom I consider to be outstanding and they all have similar characteristics," says Heather. "They connect individually with their students, and encourage and challenge them to reach beyond their comfort zone."

"Discovery consists of looking at the same thing as everyone else and thinking something different."
—Albert Szent-Gyorgyi

SURPRISES & DISCOVERIES

Through art forms including drawing, painting, print-making, and a pin-pricking method that she calls "pinhole," Heather creates dynamic mixed-media pieces that are both thought-provoking and beautiful. She uses her art as a means of exploration—examining the relationships that exist between patterns, textures, words, and imagery when layered onto each other. "I enjoy the element of surprise in making art, and the sense of discovery through the act of creating," she says.

Heather's work with students of the Arts-Based Preschool at The Lawrence Arts Center in Lawrence, Kansas is also full of surprises and discoveries. One of the things that she loves most about teaching her young students is their excitement about "the process of making." Says Heather: "They arrive each day eager to work. And they are often surprised and amazed by what they make, because when they immerse themselves in the creative process they don't always know where it will lead."

POINT OF VIEW

Heather's keys to inspired and authentic living

- I make time for quiet and a walk outdoors every day, both of which help me mentally sort through my current projects (including those that are unrelated to my art).

- Every year, I challenge myself by taking workshops in different media so that I can learn how to use a variety of materials and try other ways of working. Doing so helps to bring new direction to my work.

- When I'm ready to move on from making a certain type of art, I do so, regardless of what anyone else expects or wants me to do. It is important that I make art that is honest, that has meaning, and that I like instead of pleasing others.

UNEXPLORED TERRITORY

More than providing her students solely with art-making abilities, Heather seeks to use creativity to build critical-thinking skills and self-esteem in those she teaches. "Our program encourages children to be problem-solvers and individual thinkers," she says. "We want them to feel proud of themselves and not look to a 'grown-up' for approval. It's important for them to be motivated by their own sense of worth rather than seeking it from someone else."

Having frequent opportunities to see art through the eyes of children has also informed the way that Heather approaches her own creative methods. "Preschoolers are very aware of their process, and most of what they do is new or unexplored territory for them," she says. "From them, I have learned to keep fresh eyes about what I am making ... to recognize the process and to continually embrace the experience of making something."

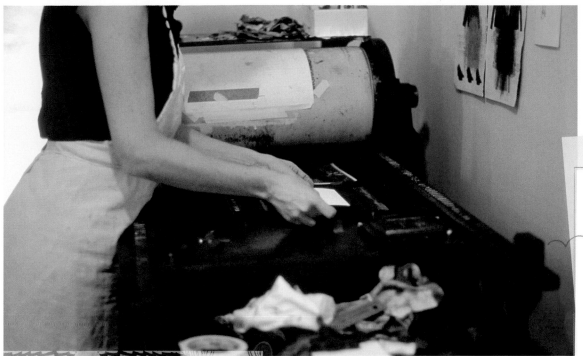

she laughs

In our classroom, every day is a "laugh out loud" kind of day, which is one of the greatest gifts of teaching children!

SKILLS TO SHARE

Heather began teaching at the college level while she was still in graduate school, which meant that she wasn't much older than her students. To overcome her apprehension, she worked hard to emphasize her strengths as both an educator and an artist. Now, she teaches in what she calls "an ideal situation," where she leads the classroom in tandem with another instructor. "We work as a team," she says, "so that we can be there to facilitate those children who need a little prompting and also be artists alongside them from time to time."

Whether she's teaching a workshop filled with children or adults, Heather knows that every student has a unique gift to offer. She says: "Each person is good at something, and has something for which they are passionate; it's simply a matter of recognizing what that is. I would like for the students I teach to realize, especially during times when they become frustrated, that they have valuable ideas and skills to share."

CREATING WITH HEATHER:
MIXED-MEDIA
NATURE STUDY

This project explores shapes and patterns from the natural world by using basic print-making techniques to create spontaneous layers. Though a few specific materials are required, similar effects can be achieved by using a wide variety of printing implements, including fabric, wood, rubber stamps, and linoleum.

what you'll need

- 1 piece of thick paper, such as watercolor paper
- bees' nest (or other natural element)
- paints (such as watercolors, gouache or acrylics)
- colored pencils
- paintbrushes
- rosehip (or other natural element)
- textured surface (such as a wooden board, or loose-weave piece of fabric)
- ink
- brayer
- metal spoon
- printing implement (such as a rubber stamp, linoleum, wood block, or letterpress)

techniques you'll learn

- texturing
- print-making
- painting and/or drawing

one

Select an object from nature, such as the bees' nest used in Heather's piece, and study the shapes that exist within it. Create a linear pattern across the entire background of your paper, using either paint or colored pencils.

two

Choose another natural element, like the rosehip selected by Heather, and paint or draw it on top of the pattern. Look closely at the object, and create a solid, realistic representation of it on your piece.

three

Find a surface that has a raised or rough texture, such as a wooden board or a loosely-woven fabric, to use to create a print. Apply ink onto the textured piece using a brayer. Print directly on top of your artwork by placing it face-down onto the inked surface and rubbing the back with the rounded side of a metal spoon. Lift the print off of the textured piece and allow it to dry.

four

Following the technique used in step three, add an image to the top of your piece using a rubber stamp, piece of linoleum, wood block, or other printing implement. Heather used letterpress to add the ship image to her artwork, but you can use any printing material that is readily available to you.

create with Heather at:

- The Lawrence Arts Center
 (*www.lawrenceartscenter.org*)

five

Use paint to emphasize shapes, add shading, write words or phrases, or add other details as desired.

six

Create layers of tones, from light to dark, by using varying concentrations of one color.

ideas & variations

- The steps used to create this project can be done in any order; try doing the printing stages first and then applying the painted or drawn elements over the top for a different effect.

- This project is all about experimentation, so feel free to add your own steps and interpretations to put your own spin on it.

ABOUT THE CONTRIBUTORS

Sarah Ahearn Bellemare is a mixed-media painter who creates her layered works in New England, and frequently teaches at retreats across the country. Visit Sarah's blog at *sarahearn.blogspot.com* to learn more about her or to find information about upcoming workshops.

Flora Bowley lives and works in Portland, Oregon, and shares her soulful style of painting with fellow artists at workshops held in colorful locations around the world. Keep up with Flora by visiting her blog at *florabowley.typepad.com* or her website at *www.florasbowley.com*.

Alisa Burke is a painter, mixed-media artist, and author who teaches her graffiti-inspired techniques at workshops nationwide. To learn more about Alisa, see her current class schedule, or participate in one of her online workshops, visit her website at *www.alisaburke.com* or her blog at *alisaburke.blogspot.com*.

Maya Donenfeld is a wife, mother, artist, maker, gatherer, and reinventor who lives with her family in rural New York, and travels around the U.S. teaching eco-chic art classes. Follow Maya's adventures by visiting her blog at *mayamade.blogspot.com*.

Julie Haymaker Thompson creates whimsical sculptures, mixed-media shadowboxes, and paintings at her studio in Santa Fe, New Mexico. To learn more about Julie or her frequent workshop appearances, visit her website at *www.juliehaymaker.com* and her blog at *juliehaymaker.blogspot.com*.

Tracie Lyn Huskamp is an artist and dreamer who brings her nature-inspired style of art-making to mixed-media works, fabrics, calendars, books, and workshops. Visit Tracie's blog at *thereddoor-studio.blogspot.com* to learn more about her and her art, and to get updates on her future class offerings.

Lisa Kaus is a mixed-media artist based in the Pacific Northwest who regularly teaches her signature painting and collage techniques to fellow artists at workshops held across the country. Follow Lisa on her blog at *lisakaus.blogspot.com* or by visiting her website at *www.lisakaus.com*.

Mati Rose McDonough is a painter, illustrator, and collage artist who encourages other artists to embrace their inner child during her popular classes. Keep up with Mati and her upcoming workshop appearances by visiting her website at *www.matirose.com* and her blog at *matirose.blogspot.com*.

Roxanne Padgett is a mixed-media artist with a love for color who combines paint, paper, and fabric in eye-catching, stitched creations. Visit Roxanne's blog at *arthouse577.blogspot.com* to find out more about her and to see an up-to-date schedule of her popular art classes.

Stephanie Jones Rubiano is a former environmental scientist turned full-time artist who transforms vintage photographs into mixed-media art with a touch of humor, and shares her methods with others during workshops throughout the year. Learn more about Stephanie and her artwork on her website at *www.stephanierubiano.com*.

Mary Beth Shaw is a mixed-media artist and painter who can often be found splattered with paint and running with scissors as she creates complex, layered works of art. Learn more about Mary Beth and her busy workshop schedule by visiting her blog at *mbshaw.blogspot.com* and her website at *www.mbshaw.com*.

Heather Smith Jones is an author, painter, mixed-media artist, and teacher who shares her love of the arts with preschool students at the Lawrence Arts Center located in Lawrence, Kansas. To learn more about Heather or her debut book, *Water Paper Paint: Exploring Creativity with Watercolor and Mixed Media*, visit her website at *www.heathersmithjones.com*.

Carla Sonheim is a painter, illustrator, and teaching artist known for her fun and innovative projects and techniques designed to help students uncover a more spontaneous, playful approach to creating. Follow Carla's blog at *carlasonheim.wordpress.com* to learn more about her and for information about upcoming workshops.

Alma Stoller is an active and prolific artist who dabbles in media ranging from painting and collage to crochet and textile art, and encourages other artists to "create out loud" at workshops held nationwide. Visit Alma's blog at *almastoller.blogspot.com* for updates, tutorials, and class schedules, or her arts and crafts blog, The Glossy Project, at *theglossyproject.blogspot.com*.

LIST OF EVENTS

U.S.A.

An Artful Journey
Classes Include: Mixed-Media, Jewelry-Making, Painting
www.anartfuljourney.com

Artfest
Classes Include: Mixed-Media, Jewelry-Making, Painting
www.teeshaslandofodd.com/artfest/info.html

Artinfusio
Classes Include: Mixed-Media, Painting, Journaling
sweetsistergina.typepad.com/artinfusio

Artistic Bliss
Classes Include: Mixed-Media, Jewelry-Making, Doll-Making
artisticbliss.typepad.com

Art & Soul
Classes Include: Mixed-Media, Jewelry-Making, Journaling
www.artandsoulretreat.com

A Work of Heart Studio
Classes Include: Mixed-Media, Jewelry-Making, Painting
www.aworkofheart.com

Colorado Collage Conference
Classes Include: Mixed-Media, Collage, Sewing
studioretreats.ning.com/page/colorado-collage-conference

Creativity for the Soul
Classes Include: Painting, Journaling
www.creativityforthesoul.com

EncaustiCamp!
Classes Include: Mixed-Media, Jewelry-Making, Painting
www.encausticamp.com

Hudson River Valley Art Workshops
Classes Include: Quilting, Embroidery, Fabric Painting
www.fiberartworkshops.com

Idyllwild Arts
Classes Include: Jewelry, Ceramics, Mixed-Media, Calligraphy
www.idyllwildarts.org

Journalfest
Classes Include: Journaling, Lettering, Drawing
www.teeshaslandofodd.com/journalfest/info.html

The Makerie
Classes Include: Mixed-Media, Jewelry-Making, Painting
www.themakerie.com

Silver Bella
Classes Include: Mixed-Media, Jewelry-Making, Photography
www.paperbellastudio.com/pages/silverbella.htm

Sock Summit
Classes Include: Knitting
www.socksummit.com

Squam Art Workshops
Classes Include: Mixed-Media, Sewing, Knitting
www.squamartworkshops.com

Teahouse Studio
Classes Include: Photography, Painting, Self-Discovery, Altered Books
www.teahouseartstudio.com

Textile Evolution
Classes Include: Beading, Mixed-Media, Sewing
www.textileevolution.com

Valley Ridge Art Studio
Classes Include: Mixed-Media, Jewelry, Painting
www.valleyridgeartstudio.com

INTERNATIONAL

Adventures in Italy
Classes Include: Mixed-Media, Quilting, Painting
www.adventuresinitaly.net

Crafty Chica Art Cruise
Classes Include: Mixed-Media, Jewelry-Making, Journaling
thecraftychica.blogspot.com

Do What You Love Art and Creative Enterprise Retreat
Classes Include: Mixed-Media, Painting
www.dowhatyouloveforlife.com/retreat

Scrapmap
Classes Include: Mixed-Media, Scrapbooking, Photography
www.scrapmap.com

ONLINE

Alisa Burke's Online Workshops
Classes Include: Mixed-Media, Painting, Color Theory
www.alisaburke.com/workshops/onlineworkshops.html

Carla Sonheim's Online Workshops
Classes Include: Drawing
carlasonheim.wordpress.com

CRESCENDO*h* Creative Lab
Classes Include: Mixed-Media, Quilting, Creative Development
creativelab.crescendoh.com

Do What You Love e-Course
Classes Include: Creative Development
www.dowhatyouloveforlife.com/e-course/

Elsie Flannigan's Online Workshops
Classes Include: Blogging, Photography, Personal Style
abeautifulmess.typepad.com/my_weblog/e-course-catalog.html

evbstudioHOME
Classes Include: Clay Sculpture
evbstudiohome.ning.com

LK Ludwig's Online Workshops
Classes Include: Photography, Journaling
gryphonsfeather.typepad.com/the_poetic_eye/onlineworkshoplist.html

Shabby Cottage Studio
Classes Include: Mixed-Media, Lettering, Painting
www.shabbycottagestudio.com/store/WsDefault.asp?Cat=ONLINECLASSES

wishBIG ecamp
Classes Include: Photography, Creative Development
wishstudio.com/events/

PHOTO CREDITS

INDEX